MAKE ART NOT WAR

Edited by

RALPH YOUNG

MAKE

POLITICAL PROTEST POSTERS

NOT

ART WAR

from the TWENTIETH CENTURY

WASHINGTON MEWS BOOKS
An imprint of
NEW YORK UNIVERSITY PRESS New York

WASHINGTON MEWS BOOKS
An imprint of
NEW YORK UNIVERSITY PRESS
New York
www.nyupress.org

© 2016 by New York University
All rights reserved

References to Internet websites (URLs) were accurate at the time of writing. Neither the author nor New York University Press is responsible for URLs that may have expired or changed since the manuscript was prepared.

ISBN: 978-1-4798-1367-4

For Library of Congress Cataloging-in-Publication data, please contact the Library of Congress.

New York University Press books are printed on acid-free paper, and their binding materials are chosen for strength and durability. We strive to use environmentally responsible suppliers and materials to the greatest extent possible in publishing our books.

Manufactured in the United States of America

10 9 8 7 6 5 4 3 2 1

Also available as an ebook

To the memory of my mother and father,

Emily Mildred House Young

Ralph Eric Young

CONTENTS

TWO of the most recognizable images of twentieth-century art are the most famous painting by that most famous of twentieth-century artists, Pablo Picasso's *Guernica*, and the rather-modest mass-produced poster by an unassuming illustrator, Lorraine Schneider, "War is not healthy for children and other living things." From Picasso's masterpiece to a humble piece of poster art, artists have used their talents to express dissent, to protest against injustice and oppression, to reveal publicly to the world their strong objection to the actions of the powerful. Visual art, whether high art or posters, broadsides or fliers, cartoons or comic books, murals or graffiti has been used effectively by dissenters to push for change, to protest inequality and discrimination, in a high-minded effort to bring about a better world. Visual art is one of the many valuable tools by which protestors have expressed and promoted their dissenting points of view.

. . .

INTROD

The United States is a product of dissent. Religious dissenters, unable to worship according to their own lights, left England, the Netherlands, Rhineland/Palatinate, Scotland, and Ulster to plant colonies in the New World. By the mid-eighteenth century, political dissenters took their protests against what they perceived as a tyrannical government in London so far as to fight a war for independence that culminated in the creation of the United States of America. And they conspicuously inserted the right to dissent in the First Amendment of the nation's founding document.[1]

Americans have taken that right seriously ever since. Whenever the power structure seemed to be overstepping its bounds or whenever people felt the government was not fulfilling its duty to protect everyone's natural rights, Americans have dissented. And they have expressed their discontent in a wide variety of ways: writing letters, broadsides, and polemics; preaching sermons and delivering speeches; conducting protest marches in the streets; or engaging in acts of civil disobedience. Dissenters have used literature, poetry, music, dance, comedy, cinema, theater, street

theater, and puppetry to castigate the establishment. Whether it was women fighting for the right to vote or abolitionists seeking to destroy slavery or pacifists protesting against World War I or workers demanding the right to organize or beatniks and hippies denouncing middle-class mainstream values, dissenters employed every method imaginable to condemn policies and actions that they deemed unacceptable in a democracy. From Abigail Adams to Alice Paul, from Frederick Douglass to John Brown, from Eugene V. Debs to Martin Luther King Jr., from Mark Twain to Allen Ginsberg, from Joe Hill to Phil Ochs, from H. L. Mencken to Lenny Bruce, Americans have done their best to change the status quo.

We have seen how successful demonstrations and acts of civil disobedience have been in accomplishing at least some of the dissenters' goals. One thinks of suffragists picketing the White House until the passage of the Nineteenth Amendment and civil rights activists marching from Selma to Montgomery, which led to the Voting Rights Act of 1965, or the Stonewall Riots that kicked off the gay rights movement. In many protests, music has been especially effective in getting the message out to masses of people. The protest music of the 1960s, benefiting from technological advances in radio, television, and the recording industry, got civil rights and antiwar messages out to millions of Americans who had previously been indifferent to the African American struggle for equality and the escalation of the Vietnam War. And the legacy of singers like Pete Seeger and Bob Dylan has had an enormous influence on dissent movements ever since. Along with protest music, visual artists too have used their talents to support dissenting views. Political cartoons, comic books, graffiti, murals, posters, photography, and high art have all been productively used, with varying yet frequent success, in voicing discontent.

In the colonial period, the primary pictorial devices furthering contrarian views were broadsides and cartoons. As defiance against London's taxation

policies and steadily increasing arbitrary rule in the aftermath of the French and Indian War, groups such as the Sons of Liberty posted broadsides in public places denouncing the Stamp Act, the Tea Act, the "Intolerable Acts," and other decrees and laws enacted by Parliament. Many of these broadsides were informational, raising public awareness of a regulation that was going to impose hardship on the colonists, but most of them were nothing short of propaganda, with bold-printed exclamatory headlines, for the sole purpose of inflaming public opinion in order to gain adherents to the patriot cause. Samuel Adams, one of the leaders of the Sons of Liberty, had fine-tuned propaganda into an art that became the forerunner of the protest posters of the twentieth century. One of Adams's comrades in the Sons of Liberty was the celebrated printer/engraver Paul Revere. Revere used his talents to print engravings protesting London's policies. His most famous engraving was the volatile image he produced of the Boston Massacre, transforming the unruly, menacing mob into peaceful middle-class citizens out for a stroll and depicting the redcoats who were guarding the customs house as malicious, murderous scoundrels.

Political cartoons were also an influential method of expressing dissent in the buildup to the American Revolution. Cartoonists in the colonies and in Britain who supported the colonists' grievances were withering in their sarcastic caricatures of the king and his Tory ministers. America was usually depicted as a virtuous young woman and Parliament as would-be (or actual) ravishers trying to destroy the virtue of honorable colonists.

By the nineteenth century, political cartoons published in newspapers and periodicals were the favorite means of expressing dissenting views. Whether taking on the imperial presidency of Andrew Jackson or denouncing slaveholders or free-soilers or Irish immigrants or the war hawks leading the country into the War of 1812 or the southerners pushing for a war with Mexico in the 1840s, political cartoons had

a considerable impact on shaping public opinion. The artists sketching their cartoons and caricatures used humor and sarcasm, poignancy and moral outrage to express their anti-status-quo views. As is frequently the case with political cartoons, they often overstepped the bounds of propriety. One thinks of the many nativist, anti-immigrant cartoons that were published in the aftermath of the Irish potato famine, depicting Irish immigrants as sideshow freaks or unintelligent beasts.

Posters too were popular methods of protesting against societal problems and the government's inability, indeed unwillingness, to do something about those problems. One of the most emotive posters published by the temperance movement, "The drunkard's progress," depicted the nine steps to descending into an alcoholic hell, each step showing the degeneration of a man from "a glass too much" to "poverty and disease" and eventual "death by suicide." Union activists also utilized posters and fliers to notify workers of strikes, industrial action, and rallies and as a recruitment tool. Molly Maguires and other mineworkers in the 1870s, anarchists and radical union organizers at Haymarket Square in 1886, and railway workers during the massive strikes of 1877 and 1894 all used posters to inform and enlist picketers.

High culture too contributed to visual protest in the nineteenth century. Realist artists of the so-called Ashcan School criticized the soul-destroying inequality that became more and more prevalent during the Gilded Age. Artists like William Glackens, Robert Henri, George Luks, and John Sloan produced paintings that forced people to consider the harsh realities of urban industrial life—the squalor of the slums, rats rummaging in trash cans, industrial pollution filling the air, raw sewage in the streets. There was nothing romantic or aesthetically appealing in their paintings; their goal was to challenge public apathy and persuade Americans to call for new laws and policies that would address inequality and poverty.

By the turn of the century, a new form of graphic art was already beginning to be used to promote dissenting views and stimulate change: photography. Jacob Riis and Lewis Hine spearheaded the use of photography as a means for social reform. Both men chronicled the overcrowding of urban slums, homelessness, sweatshops, and especially the plight of children forced to work in textile mills, coalmines, and factories. Their images seared the public consciousness and inspired many Americans to get involved in the campaigns to alleviate the suffering of the poor and to end the exploitation of children. And throughout the twentieth century, photography became an increasingly effective tool for expressing dissent. Dorothea Lange, Margaret Bourke-White, and Walker Evans were among the many photographers whose images of families and individuals devastated by the Great Depression moved the nation in ways that no speech or pamphlet could. And the influence of photography on social reform only increased through the proliferation of magazines like *Life*, *Look*, and *Collier's* that reached a mass audience.

Photography had an impact on other forms of visual dissent, most notably high art and poster art. Edward Hopper's realist paintings depicting loneliness and alienation have an almost black-and-white photographic sensibility about them. For example, his 1942 painting *Nighthawks*, depicting three customers and an employee in an all-night diner in New York City, conjures a longing to overcome the isolation that separates and even overwhelms individuals living in an alienating urban environment. Later, in the 1960s, pop artist Andy Warhol employed photographic technique in his paintings and silkscreens. Whether it was Campbell's tomato soup or the assassination of John F. Kennedy, the endless reproduction of images again and again was his sardonic commentary on the mass-produced nature of daily life in modern America.

There is nothing photographic to be sure in the paintings of the postwar abstract expressionists. Like modern jazz bebop musicians who broke

all the rules of harmony and structure, artists like Jackson Pollock, Robert Motherwell, and Mark Rothko abjured all the accepted rules of painting in their critical vision of living in a post-Hiroshima world. Their paintings in the 1950s seemed (whether consciously or unconsciously) to reflect critically on the no-holds-barred anxiety unleashed by the Cold War and the apparent inability of the superpowers to restrain the nuclear arms race.

The long tradition of political cartoons continued and expanded in the twentieth century. Cartoonists in nearly every newspaper and periodical in the country constantly exposed the idiosyncrasies and foibles of politicians, the ill-advised policies of lawmakers, and rampant political corruption. And they protested against just about everything. Cartoonists expressed antiwar, antiunion, anti-immigrant, anticommunist, antiabortion sentiments as well as prowar, prounion, pro-immigration-reform, procommunist, and pro-choice opinions.

Some cartoonists used comic book art to protest against authority. *Mad* magazine, starting in 1952, offered a hilarious send-up of American politicians, cultural icons, and Cold War propaganda (on both sides) that helped an entire generation cope with indoctrination and anxiety. Robert Crumb began drawing his *Zap Comix* in the 1960s, ridiculing middle-class values and extolling the countercultural lifestyle. Puppetry was also used in an imaginative way, especially during the Vietnam War. The Bread and Puppet Theater regularly participated in antiwar demonstrations, parading with huge papier-mâché caricatures of Lyndon Johnson, Richard Nixon, Henry Kissinger, Uncle Sam, and other icons of the military-industrial complex.

Creative artists also employed cinema effectively to express dissent. Movies like *The Grapes of Wrath* in 1940 and *Wall Street* in 1987 were critiques of the abuses of capitalism, while *All Quiet on the Western Front*

in 1930 and *Born on the Fourth of July* in 1989 were stirring antiwar films. And documentary filmmakers like Michael Moore and Laura Poitras, whose riveting films *Fahrenheit 9/11* and *Citizenfour*, respectively, gave voice to dissenters and have exposed millions of viewers to persuasive critiques of US policies.

Another form of visual dissent that has been used in the twentieth century is mural art and its offspring graffiti. Mural art projects began in a big way during the New Deal when the Works Progress Administration provided funds to employ out-of-work artists. Thousands of young artists painted thousands of murals on post offices and schools and other buildings being constructed by the WPA. (Some of these young artists later became famous, most notably Jackson Pollock and Mark Rothko.) State governments also commissioned artists to paint murals on state buildings. While most of the murals that were commissioned depicted patriotic American scenes, many of the artists inserted social commentary messages into their work—juxtaposing images of destitute workers alongside rich yachtsmen or of a white woman sitting next to a black man on a subway car (which would certainly have offended many people at a time when segregation was the norm) or depicting a woman hanging wash in the yard of her slum dwelling. Some muralists admitted that they were indeed trying to bring about social and political change through their art. Thomas Hart Benton, for example, in his mural *Social History of the State of Missouri*, which he painted for the Missouri state capitol, unflinchingly portrayed many controversial episodes in Missouri history, such as the expulsion of the Mormons; slaves being auctioned; Frank and Jessie James, the fabled outlaw brothers who stole from the rich and gave to the poor; and the suffering brought on by the Great Depression. Benton's goal through such images was to raise social consciousness and generate reflection and discussion. Expressing views that go against the establishment's grain, that resist the whitewashing that the authorities always seem to strive for, is a major goal of such

mural artists. And it has reverberated around the world. One thinks of the poignant murals painted in the Northern Ireland city of Derry by the Bogside Artists, who have labored intensely to make sure viewers ponder what happened in that city during the "Troubles" and the killing of fourteen unarmed civil rights protestors by British paratroopers on Bloody Sunday, 30 January 1972. Cities around the world are filled with murals that compel people to think about things they might not want to think about.

Graffiti works in much the same way. In a sense, graffiti is an even more democratic form of mural art, and it has become a truly international phenomenon. Much of it is spray-painted by anonymous folk who are seeking to voice their own view, often on controversial aspects of modern-day life. Frequently graffiti artists are consciously making a political statement, but often the message is simply in the rebellious act of creation itself. Whether they are painting on subway walls in New York City or fences around Union Station in Los Angeles or tenement walls in Lisbon or Rio or the Berlin Wall or the West Bank barrier, individuals, mostly nameless, ordinary people, are (as Bob Dylan observes in "Love Minus Zero / No Limit") "draw[ing] conclusions on the wall." Or, as Paul Simon once put it (in "The Sounds of Silence"), "the words of the prophets are written on the subway walls and tenement halls." Most graffiti artists remain anonymous, but there are many celebrated ones whose works have been acclaimed around the world—Dondi (Donald White), Revok (Jason Williams), Lady Pink (Sandra Fabara), and the mysterious British artist Banksy.

On a smaller scale is one of the most prolific forms of dissent art and one that has been around throughout the nation's history: posters. Technological advances in the twentieth century in photography, silk-screening, and mass-produced printing have made posters an especially suitable (and economical) way to get out a dissenting message.

Like broadsides before them, posters are informative, but they are also an extremely effective way to dramatize a specific point of view. Suffragists, labor organizers, civil rights organizations, antiwar activists, draft resisters, countercultural rebels, and antiabortion militants have produced and distributed millions of posters in an attempt to influence public opinion and governmental policy. From posters urging workers to join the IWW or SNCC to the aforementioned Lorraine Schneider's "War is not healthy for children and other living things" or the image of a protestor publicly burning his draft card under the caption "Fuck the draft," protest posters have swayed people to enlist in dissenting causes throughout the twentieth century. Activists published posters supporting civil rights, gay rights, feminism, Chicano farm workers, the American Indian Movement, and animal rights, while others created posters denouncing the draft, Lyndon Johnson, Richard Nixon, atrocities that American soldiers were committing in Vietnam, *Roe v. Wade*, corporate greed, and the military-industrial complex. To this day, dissenters such as the Black Lives Matter movement produce posters proclaiming "Hands up don't shoot" to protest police killings of unarmed black men, while the Guerrilla Girls, a feminist artist group, continues its thirty-year campaign with evocative protest posters cheekily raising the question, "Do women have to be naked to get into the Met. Museum?"

■ ■ ■

In the Tamiment Library at New York University, there is a rich collection of political protest posters that are part of the long tradition of using graphic art to express and propagate dissenting opinions. The posters housed in the collection cover many of the dissent movements of the twentieth century, especially the second half of the century: labor, civil rights, the Vietnam War, American imperialism, feminism, gay rights, and other minority-rights movements. The samples from the collection reproduced here are grouped (chronologically as far as possible) according to subject: labor/socialism, civil rights/apartheid, antiwar/

counterculture, feminism, minority rights. This is somewhat arbitrary because some of the posters have overlapping themes.

At the turn of the twentieth century, the Progressive movement demanded federal action to rein in the insatiable greed of the robber barons, to protect the victims of industrialism, and to do something about poverty and income inequality. With Theodore Roosevelt in the White House, there was some reform; but for many progressives, it was not enough, and some of them turned to more radical remedies. In 1894, the president of the American Railway Union, Eugene V. Debs, was arrested for leading the ARU's strike against the Pullman Company. During his trial, the prosecution repeatedly accused him of being a socialist. Sentenced to six months in prison, Debs, curious, spent his time reading socialist and communist manifestoes and wound up converting to socialism. Upon his release, Debs founded the Socialist Party of America. Also around the turn of the century, the anarchist Emma Goldman and other radicals like Victor Berger, Big Bill Haywood, Joe Hill, and the communist Elizabeth Gurley Flynn worked diligently to convince workers to unite in order to overthrow the capitalist system. They, and others, organized the most radical of the labor unions in 1905, the Industrial Workers of the World (aka "Wobblies"), which called for the destruction of capitalism and the establishment of a socialist America. Thus, in the first two decades of the twentieth century, the labor movement became a central feature of radical politics in the US, and one of the chief means union organizers used to gain recruits and spread the anticapitalist message was through fliers and posters. Several of the posters reproduced in *Make Art Not War* are from the IWW. Even though the federal government persecuted the Wobblies during the first Red Scare to the point of almost destroying the union, the IWW continued to exist. Even today, it is still functioning, although nowhere near the strength it had exhibited during the heyday of Hill, Goldman, Flynn, and Haywood. The posters in figures 44–46 are from the 1960s

IWW and deal with draft resistance and the antiwar movement. The posters in figures 45 and 46 have also been combined and printed as a single poster. The Elizabeth Gurley Flynn poster (c. 1955) was an advertisement for a public address this founding member of the IWW delivered in Pittsburgh.

There are many other prolabor posters in the Tamiment collection. One of them (figure 11) urges workers to vote for the American Labor Party candidate for mayor of New York in 1949, Congressman Vito Marcantonio (he lost). Figure 13 is a Jewish Labor Committee poster calling attention to how racism and religious bigotry are manipulated by the bosses to undermine the labor movement. There are three American Postal Workers' Union posters, one of them (figure 21) proclaiming the APWU's solidarity with Martin Luther King Jr. on the twentieth anniversary in 1983 of the March on Washington and two (figures 19–20) protesting Reagan's budget cuts in 1985. "It's our turn" (figure 17) was part of a boycott campaign against Farah slacks, which was the largest producer of men's trousers in the 1970s. Activists protested the sweatshop conditions that its workers, mostly Chicanos, were forced to endure. The poster calling for the boycott of TWA (figure 18) supported the Independent Federation of Flight Attendants, which was in the midst of a strike in 1986 protesting the airline's unsafe flying conditions and the unfair pay cuts forced on flight attendants. "There are but two sides in a war" (figure 63) calls for the international community to boycott the giant oil corporation Gulf for its practices in Angola. Gulf Oil was financing the Angolan government's military operations against the people of Angola in exchange for a sweetheart deal to exploit the country's oil resources. Other labor posters in the collection support subway employees' rights, urge workers to register to vote, especially during World War II, and call for workers around the country to march in solidarity with all international workers on May 1.

In some posters published during World War II, union sentiment coincides with the nationwide determination to defeat the Nazis as well as the administration's attempts to eliminate unscrupulous business practices and manage the war economy efficiently. The Office of Price Administration published a series of posters highlighting its efforts to control price gouging and to keep rents in check during the war. Another wartime poster (figure 8) features Tito, the communist partisan who led the fight against the Nazi occupation forces in Yugoslavia, and portrays him as a heroic freedom fighter fighting to preserve democracy in Europe. The noted Jewish artist Ben Shahn painted "This is Nazi brutality" (figure 7) when he was working for the Office of War Information. The image condemns the Nazi obliteration of the Czechoslovakian village of Lidice. In 1942, members of the Czech resistance assassinated Reinhard Heydrich, one of the chief architects of the Holocaust and the SS *Reichsprotektor* of Prague. In retribution, the Nazis razed the entire village of Lidice after killing all the men and boys (and most of the women)—more than one thousand civilians.

The most significant dissent movement of the twentieth century, civil rights, drew a great deal of inspiration from the labor movement. This is reflected in civil rights tactics, strategy, songs, and posters. The three posters (figures 28–30) produced by the Student Nonviolent Coordinating Committee (SNCC) in the early 1960s as it was ratcheting up its campaign against Jim Crow are evocative images of the challenges these young civil rights activists faced. From the sit-ins and Freedom Rides of 1960–61 to the 1964 Freedom Summer movement in Mississippi to register African Americans to vote, SNCC activists consistently put their lives on the line to bring about change in the face of the most unyielding resistance. Also in the collection is a recruitment poster (figure 27) for the National Association for the Advancement of Colored People (NAACP) and posters (figures 24–25) publicizing the August 28, 1963, "March on Washington for Jobs and Freedom" (the often forgotten actual title of the

event—economic freedom was just as important a goal for the march as political freedom), as well as other posters expressing the more radical philosophies of Angela Davis, Malcolm X, and the Black Panthers.

Something that many people forget today is that the campaign against police officers' killing unarmed black men did not just start with Michael Brown, Eric Garner, and Tamir Rice. It has been going on from the days of the civil rights movement. Many historians argue that the white backlash against the civil rights movement started as early as the passage of the Civil Rights Act of 1964 and the Voting Rights Act of 1965. In fact, the same year as the Voting Rights Act saw the beginning of President Johnson's war on crime, which continued through the administrations of Nixon, Ford, Carter, Reagan, Bush, and Clinton, accounting for the mass incarceration rate of African Americans. The posters in figures 34–38 can all be viewed as forerunners of the present-day Black Lives Matter movement. (Note that the posters in figures 35 and 36, although produced by two different groups, use the same image of a fatally shot African American man to protest police brutality.) Figures 37 and 38 also reflect white student anger at the heavy-handed violence of the police in putting down both civil rights and antiwar demonstrations. Several posters in the Tamiment Collection also show the link between the civil rights movement in the US and the antiapartheid movement that was rapidly intensifying in South Africa at this time.

Civil rights inspired millions of people in the 1960s—especially youthful baby boomers who had just made the transition from high school to college. With change taking place at an accelerating pace, especially in the aftermath of the assassination of John F. Kennedy, the intensifying of the struggle for civil rights, and the escalation of the war in Vietnam, it was not surprising that the increased political involvement of students also led to increased dissent. And so the most vocal protest to come out of the 1960s was the impassioned movement against the war in

Vietnam. And tied in with the antiwar movement was the countercultural rebellion against authority and seemingly *all* American values. Both these movements grew gradually at first, but by the end of the decade, they were dominating political discourse. Whether the antiwar activists and long-haired "hippies" were being denounced as unpatriotic, un-American, or communists or were being hailed as the wave of a new revolutionary spirit, everyone seemed to have an opinion about them.

One of the disturbing antiwar images is the poster in figure 48, depicting the American eagle dropping bombs on unarmed Vietnamese peasants—an image that was unsettling to Americans who believed that the United States was always on the side of peace and freedom and democracy, that the United States was not the kind of country that would ever commit atrocities, that we were always the "good guys." And so images like this one certainly aroused passions on both sides of the argument about whether the United States should be in Vietnam. The two posters in figures 50 and 51 also display messages that were at best uncomfortable for the viewer, if not (for some Americans) outrageously disloyal. The same graphic design is the basis for both posters, but the impression is subtly different. Figure 50 conveys the moral outrage over the killing of civilians in Vietnam, whereas figure 51 expresses a more anti-imperialist message. Whatever one thought of these posters, one could not remain neutral, for such images never failed to elevate passions and generate heated argument. And of course this is part of the strategy of protest art. The illustrator *wants* to disturb and awaken people, *wants* to generate debate.

Partly because the government was dragging its heels on civil rights while simultaneously escalating the war in Vietnam and because it was clear that the American public was being fed a diet of lies about Vietnam, more and more people, especially idealistic young people, began distrusting everything about the government, everything about big business

and advertising, everything about the consumer society. *Everything*. And so we had the birth of a counterculture that questioned business, ethics, morality, religion, the American system of government. Funnily enough, they did not question democracy. They believed in democracy. And it was because of this (perhaps naïve) belief in democracy that they took to the streets and demanded that the government live up to the ideals it espoused, live up to the promise that all men are created equal, and secure the guarantees enshrined in the Bill of Rights. But when it appeared that the government was not listening, many gave up on the political process. Thus, there was this movement to "do your own thing," to renounce the powers that be, to question authority, to "Fuck authority" (yes, all authority), to reject middle-class values, grow your hair long, be natural, don't sell out to "the man," live life authentically. Throughout the 1960s and 1970s (the early 1970s were the most radical years of the 1960s), there were thousands of posters in cities around the nation (and around the world) calling for a new way to think, a new way to look at the world, a new way to value human beings.

The antiwar movement accused the United States of being the major imperialist power on earth, and growing out of that accusation in the ensuing years, American protestors denounced the imperialist policies of all subsequent presidents. Richard Nixon, Ronald Reagan, George H. W. Bush, Bill Clinton, George W. Bush—all were accused by radical protestors of turning their backs on the true birthright of this nation and leading the United States on an imperial march to dominate the world for American business and military power. These views are reflected in the posters denouncing Reagan's policies in Latin America, sponsoring the Contras, establishing himself as an imperialist president (figures 64–65). So too the images of Richard Nixon (figures 57–59) as a jack-in-the-box popping out of the television ("our master's voice"), or the diabolical Nixon faces in the poster calling for demonstrations at the 1972 Republican National Convention, or the "Tyrannus Nix?" poster. And then there is the caricature

of George H. W. Bush as Uncle Sam (figure 67), supporting the first Gulf War but neglecting education, housing, racism, corruption, and so on.

In the end, the collective experience of the 1960s spawned a host of dissent movements: Chicano rights, gay rights, American Indian rights, women's rights—a veritable mobilization of minorities. The largest of these movements was second-wave feminism, which, of course, was not a minority movement at all. Women, from the American Revolution to 1920, had fought for, and finally won, the right to vote. But almost immediately after the ratification of the Nineteenth Amendment, it became clear that the right to vote was not enough to establish equality. The experience of women in World War II, becoming a significant part of the armaments industry or the armed forces, from Rosie the Riveter to a WAC officer, was a liberating one. But returning to the role of housewife after the war was a source of deep frustration for so many women. Discontent was a festering wound. With the publication of Betty Friedan's *The Feminine Mystique* in 1963, women quickly recognized that they suffered from the "problem that has no name," and they began to do something about it. Friedan's book, along with the civil rights movement and the student movement, inspired women to organize, and by the end of the 1960s, there was a distinct radicalization of the feminist movement. Many women were influenced by the radical rhetoric of the New Left and accepted the view that capitalism itself lay at the root of women's inequality. Women who were members of such organizations as Students for a Democratic Society grew deeply disillusioned with the fact that men—all men, *including* the radicals, despite their Marxist critique of capitalist/imperialist America—were male chauvinists. In 1965, scores of women walked out of the annual SDS convention and set up women's-only consciousness-raising workshops in which they discussed how they coped with living in a male-dominated society that prevented them from experiencing the fullness of their creative potential. They learned, in these meetings, that many of them had had an illegal abortion, that

many of them had turned to psychotherapy or prescription medication to dull the ache of their everyday existence. These sessions were not only therapeutic but also a radicalization process for many of the participants. By the end of the decade, there were dozens of radical feminist groups, from Redstockings to New York Radical Feminists, from the National Association for the Repeal of Abortion Laws to the Women's International Terrorist Conspiracy from Hell (WITCH).

"If you want it done right, hire a woman" (figure 68) challenges the universal societal assumption that a woman's place is in the home by featuring an image of female war-production workers during World War II. There are also posters in the collection that call for women's participation in unions as well as posters representing more radical feminism (figures 74–79)—from "Don't call me girl!" to "Fuck housework" to the "Leave your jewels in the bank and buy a revolver" quote from the notorious Constance de Markievicz, who famously armed herself and took part in the Irish Easter Rising of 1916. As American feminism grew more and more radical and international by the 1970s, it was not uncommon to see posters quoting inspirational historical feminists: Mary Wollstonecraft, Harriet Tubman, Lucy Stone, Emma Goldman, Margaret Sanger, and Alice Paul among them.

During the last year of the sixties, the gay rights movement was born. There were of course antecedents for the movement dating back decades. The Mattachine Society, Daughters of Bilitis, and other gay and lesbian organizations had been fighting against discrimination for years. But the radical politics, civil rights demonstrations, and antiwar protests of the 1960s inspired LGBT Americans to fight against the discrimination they faced on a daily basis. Clearly, in the late 1960s, dissent was in the air. When the New York City police raided the Stonewall Inn on June 28, 1969, it was not the first time they had done so. Such raids on gay bars were a regular occurrence. But that June night, the patrons, fed

up and declaring they were not going to take such harassment anymore, spilled out onto the street in a spontaneous riot. For weeks, gay men protested and demonstrated throughout Greenwich Village; organizers formed a new organization, the Gay Liberation Front (in homage to the Vietnamese National Liberation Front); fliers and posters were drawn up and distributed throughout the city, on telephone poles, under windshield wipers, in mailboxes, calling for gay liberation, gay pride, and gay rights. Soon lesbians too organized to unite the "sisterhood," and the two movements firmly planted gay pride and sisterhood in the public consciousness. The success has been astonishingly swift. Certainly, in comparison to the amount of time it took for women suffragists to win the right to vote or civil rights activists to overturn the Jim Crow laws, it is no less than amazing that in less than fifty years the Supreme Court of the United States validated same-sex marriage. The posters in figures 80–84 are early examples of the thousands of images to come out of the gay liberation and lesbian movements.

There were many other minority-rights movements spawned by 1960s radicalism. Three of the posters (figures 85–87) show how Native Americans, like so many others, were inspired by the African American struggle for civil rights. Taking their cue from the Black Power movement, American Indians, frustrated and despairing after resisting the destruction of their culture from the first days of European colonization, began calling for "Red Power." Resistance took the form of civil disobedience, demonstrations, and occupations, most notably the takeover of Alcatraz Island in 1969 and the occupation of Wounded Knee in 1973. Both were attempts on the part of Indians to draw public awareness to their plight, with the goal of compelling the federal government to address their grievances. When they occupied Alcatraz Island in November 1969, members of the several Indian nations issued a statement proclaiming, "We are Indians! We will preserve our traditions and ways of life by educating our own children. We are Indians! We

will join hands in a unity never before put into practice. We are Indians! . . . WE HOLD THE ROCK!"[2] After a standoff between the Indians and federal officials that lasted more than a year, President Nixon sent in the FBI and federal marshals in 1971 and retook the island. The following year, hundreds of Indians embarked on the "Trail of Broken Treaties"—a caravan to the nation's capital to demand that the United States live up to all the treaties it had broken with the Indians. Legislators refused to meet with the protestors, and in the aftermath, the protesters occupied, and vandalized, the Bureau of Indian Affairs. In 1973, members of the American Indian Movement and other Native Americans took over the town of Wounded Knee (site of the 1890 massacre of Miniconjou Sioux by the US Army) and held off the FBI for seventy-one days. Eventually, a shoot-out that killed two Indians and one FBI agent ended the siege.

The Tamiment Collection is a valuable resource for historians of dissent that offers fascinating and revealing insights into twentieth-century cultural, social, and political history. The selection of protest posters assembled here is just a sampling of the riches that await the researcher.

NOTES

1 For a comprehensive history of dissent in the United States in all its forms from colonial days to the present see Ralph Young, *Dissent: The History of an American Idea* (New York: NYU Press, 2015).
2 Indians of All Tribes, "We Hold the Rock!," in *Alcatraz: Indian Land Forever*, ed. Troy R. Johnson (Los Angeles: UCLA American Indian Studies Center, 1995), 11.

Figure 1.

"Sure we'll help," United Automobile Workers Union, early 1940s.

Tamiment Library Poster and Broadside Collection (GRAPHICS 002), Flat File 7, Drawer 3, Tamiment Library and Robert F. Wagner Labor Archives, New York University.

SURE WE'LL HELP

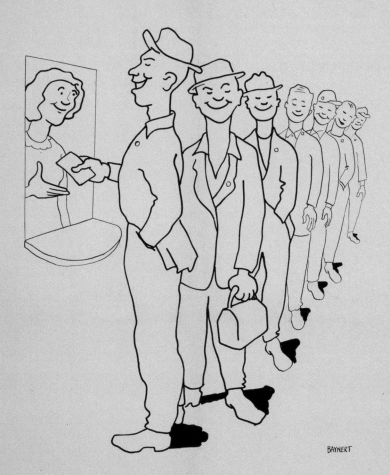

THE ASSESSMENT WILL PROTECT YOU!

"Successful organization of the aircraft industry, victory in the drive to organize competitive Shops — these are the things that must be done in coming months if the position of organized auto workers is to be protected."

George F. Addes,
Int. Secretary-Treasurer, UAW-CIO.

UAW-CIO
International Education Department
281 West Grand Boulevard
Detroit, Michigan

PRINTED IN U. S. A.

Figure 2.

"Insure your future," Greater New York CIO Political Action Committee, c. 1939.

Tamiment Library Poster and Broadside Collection (GRAPHICS 002), Flat File 7, Drawer 3, Tamiment Library and Robert F. Wagner Labor Archives, New York University.

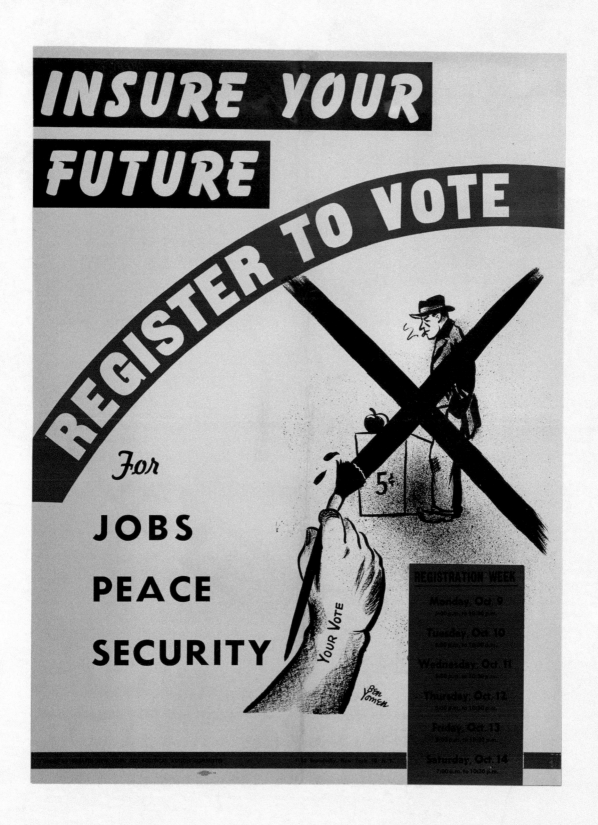

Figure 3.

"Night workers register now," Greater New York CIO Political Action Committee, early 1940s.

Tamiment Library Poster and Broadside Collection (GRAPHICS 002), Flat File 7, Drawer 3, Tamiment Library and Robert F. Wagner Labor Archives, New York University.

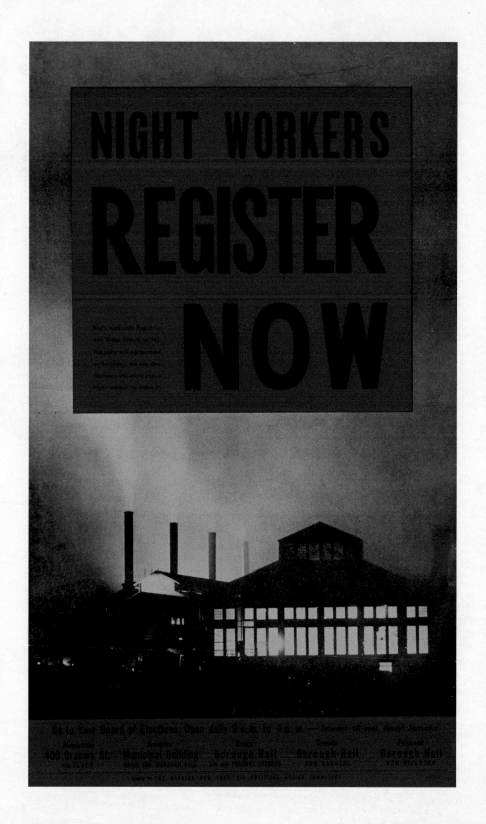

Figure 4.

"An overcharge is the same as a pay cut," United States Office of Price Administration, 1945.

Tamiment Library Poster and Broadside Collection (GRAPHICS 002), Flat File 7, Drawer 4, Tamiment Library and Robert F. Wagner Labor Archives, New York University.

Figure 5.

"Sugar is scarce," United States Office of Price Administration, 1946.

Tamiment Library Poster and Broadside Collection (GRAPHICS 002), Flat File 7, Drawer 4, Tamiment Library and Robert F. Wagner Labor Archives, New York University.

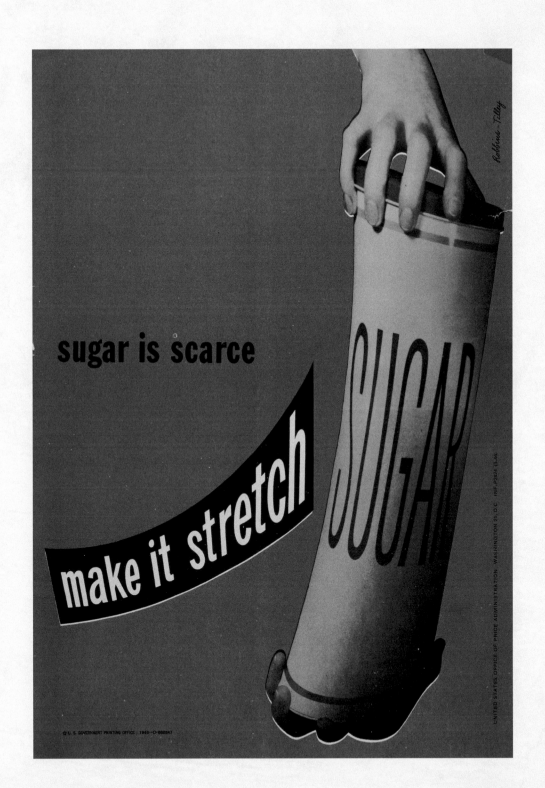

Figure 6.

"Your government is checking inflation," Frank Robbins, United States Office of Price Administration, 1946.

Tamiment Library Poster and Broadside Collection (GRAPHICS 002), Flat File 7, Drawer 4, Tamiment Library and Robert F. Wagner Labor Archives, New York University.

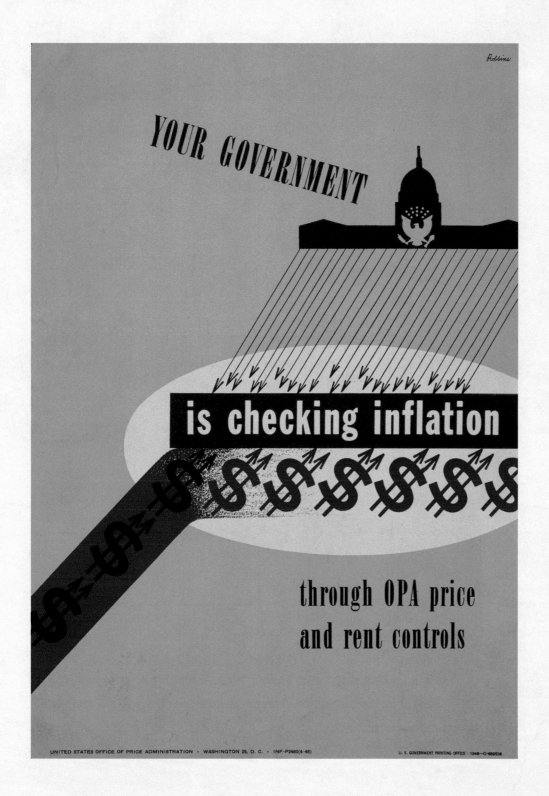

Figure 7.

"This is Nazi brutality," Ben Shahn, 1942. A graphic protest against the Nazi atrocities in Lidice, Czechoslovakia, portraying one of the victims about to be shot.

Tamiment Library Poster and Broadside Collection (GRAPHICS 002), Flat File 7, Drawer 4, Tamiment Library and Robert F. Wagner Labor Archives, New York University.

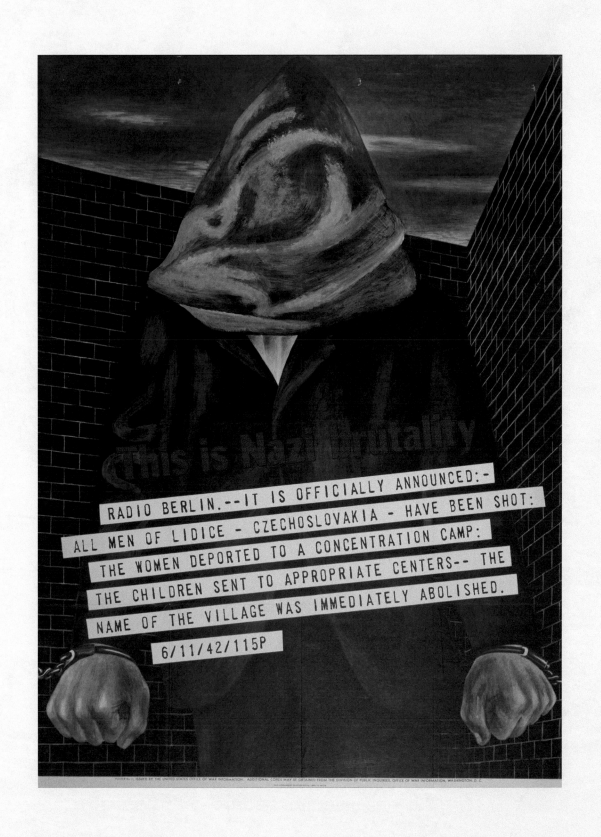

Figure 8.

"Fighting vanguard of democratic Europe," Edward McKnight Kauffer for the United Committee of South-Slavic Americans, c. 1944. A World War II antifascism propaganda poster featuring partisan leader Josip Broz Tito. After the war Tito was the dictator of Yugoslavia until his death in 1980.

Tamiment Library Poster and Broadside Collection (GRAPHICS 002), Flat File 7, Drawer 1, Tamiment Library and Robert F. Wagner Labor Archives, New York University.

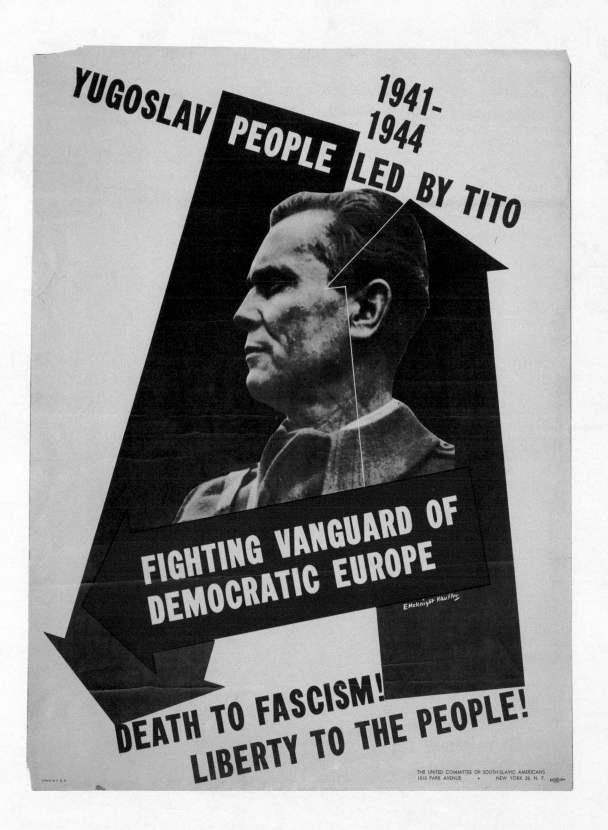

YUGOSLAV PEOPLE 1941-1944 LED BY TITO

FIGHTING VANGUARD OF DEMOCRATIC EUROPE

E McKnight Kauffer

DEATH TO FASCISM! LIBERTY TO THE PEOPLE!

THE UNITED COMMITTEE OF SOUTH-SLAVIC AMERICANS
1010 PARK AVENUE • NEW YORK 28, N. Y.

Figure 9.

"I am the subway!," Transport Workers Union of Greater New York, 1947.

Tamiment Library Poster and Broadside Collection (GRAPHICS 002), Container 1, Box 1,
Tamiment Library and Robert F. Wagner Labor Archives, New York University.

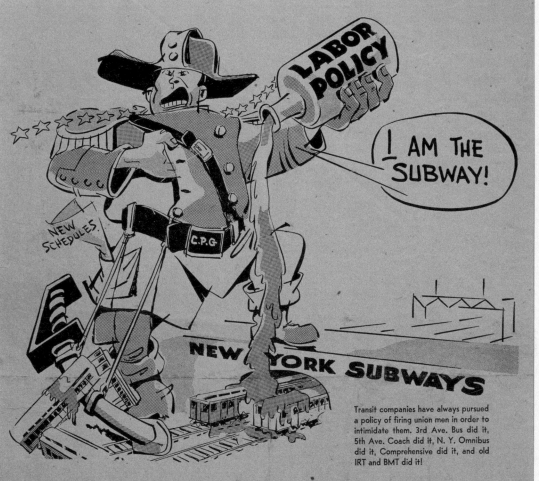

None of these companies ever got away with firing TWU men! Gross and Sullivan won't get away with it either!

TWU predicts that Kelly and Cabral will be on the job long after Gross and Sullivan (AFL) are gone!

Gentlemen of the Board: Firings are no substitute for wage increases & better pensions!

We Have Just Begun to Fight!

TRANSPORT WORKERS UNION OF GREATER NEW YORK—CIO • 153 W. 64th St., New York 23, N. Y. • 554 Atlantic Ave., Brooklyn 17, N. Y.

47

Figure 10.

"The rich have a holiday every day," artist unknown, probably 1930s. A prolabor, pro–May Day march poster from the time when May Day labor parades in New York City were well-attended, festive affairs.

Tamiment Library Poster and Broadside Collection (GRAPHICS 002), Flat File 7, Drawer 2, Tamiment Library and Robert F. Wagner Labor Archives, New York University.

THE RICH
HAVE A
HOLIDAY EVERY DAY
WORKING PEOPLE
HAVE
MAY DAY
LET'S CELEBRATE
MAY 1

Figure 11.

"Make Marcantonio mayor," Workshop of Graphic Art, 1949. Political poster for democratic socialist Vito Marcantonio's run for mayor of New York City on the American Labor Party ticket.

Tamiment Library Poster and Broadside Collection (GRAPHICS 002), Flat File 7, Drawer 4, Tamiment Library and Robert F. Wagner Labor Archives, New York University.

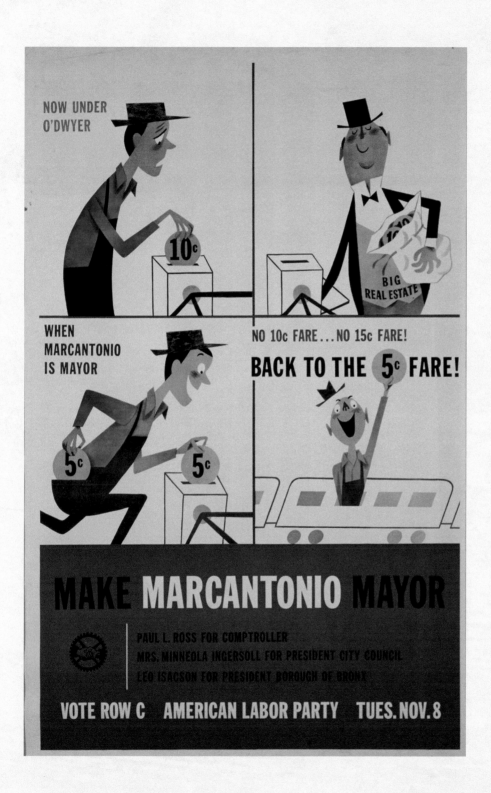

Figure 12.

"Vote and unite," Pittsburgh Communist Party, probably 1955. A poster announcing a speech by Elizabeth Gurley Flynn.

Tamiment Library Poster and Broadside Collection (GRAPHICS 002), Flat File 7, Drawer 2, Tamiment Library and Robert F. Wagner Labor Archives, New York University.

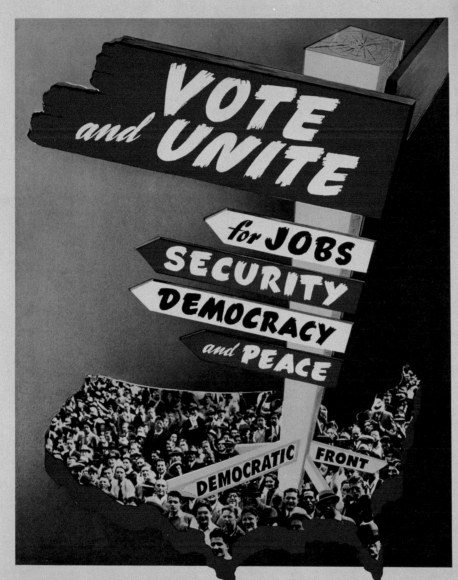

HEAR
ELIZABETH GURLEY FLYNN
AT
N. S. CARNEGIE HALL
Federal and E. Ohio Sts.
MONDAY, NOVEMBER 7th, 8 P. M.
Auspices: Communist Party, 527 Fifth Ave., Pittsburgh, Pa.

Figure 13.
"Don't be a jerk!," Jewish Labor Committee, probably 1940s. The
Jewish Labor Committee was founded in 1934 to combat prejudice
and bigotry and promote the historically strong ties between the
Jewish community and the labor movement.

Tamiment Library Poster and Broadside Collection (GRAPHICS 002), Box 1, Tamiment
Library and Robert F. Wagner Labor Archives, New York University.

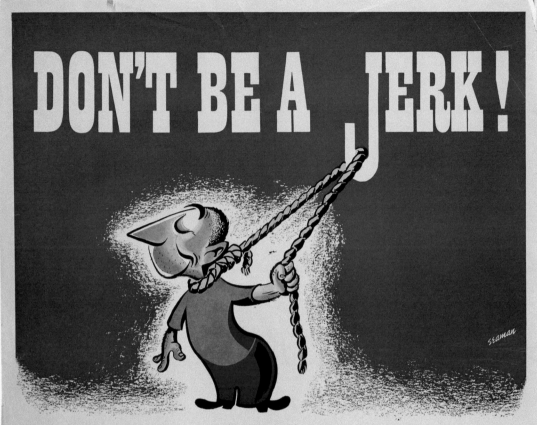

RACE AND RELIGIOUS HATE HURTS.....*YOU!*

JEWISH LABOR COMMITTEE

175 EAST BROADWAY, NEW YORK 2, N. Y.

Figure 14.

"Speedups cause breakdowns," Industrial Workers of the World, 1970s.

Tamiment Library Poster and Broadside Collection (GRAPHICS 002), Flat File 7, Drawer 2,
Tamiment Library and Robert F. Wagner Labor Archives, New York University.

Speedups Cause Breakdowns...

SUPPORT THE BREAKDOWN
OF YOUR CHOICE!

INDUSTRIAL WORKERS OF THE WORLD
★I★
W★W
UNIVERSAL
LABEL

DIST'D BY: IWW Madison Branch
Box 2605 Madison, W. 53701

INDUSTRIAL WORKERS of the WORLD

Figure 15.

"It's all ours!," Carlos A. Cortéz, Industrial Workers of the World, 1974.

Tamiment Library Poster and Broadside Collection (GRAPHICS 002), Flat File 7, Drawer 2, Tamiment Library and Robert F. Wagner Labor Archives, New York University.

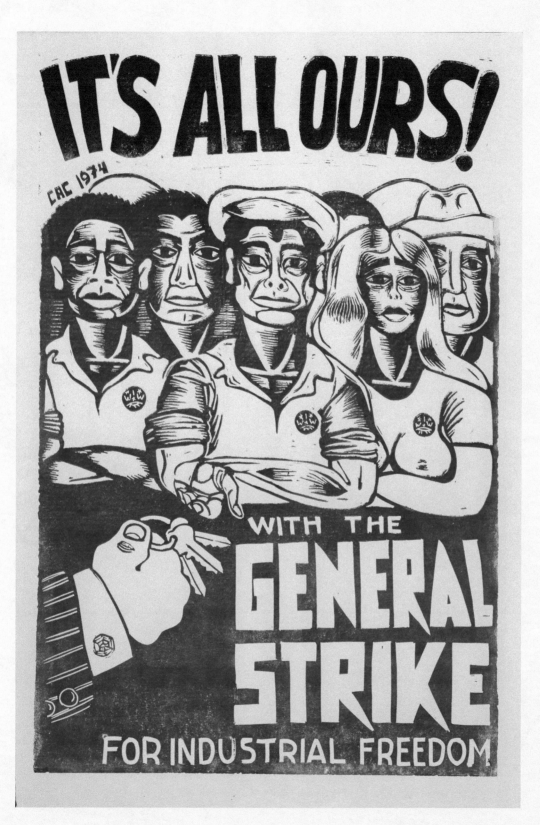

Figure 16.

"Angela Davis urges declare your independence," Hall-Tyner Election Campaign Committee, 1976.

Tamiment Library Poster and Broadside Collection (GRAPHICS 002), Flat File 7, Drawer 2, Tamiment Library and Robert F. Wagner Labor Archives, New York University.

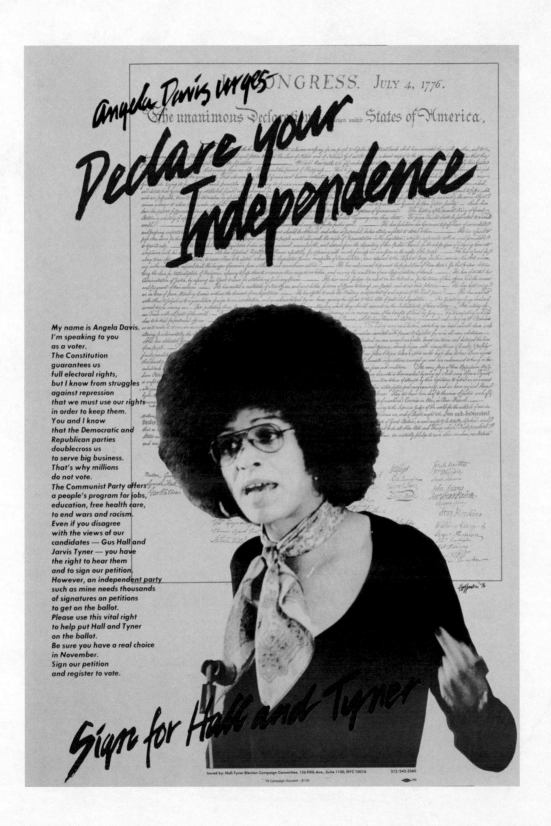

Figure 17.

"It's our turn," Burt Beck for the Amalgamated Clothing and Textile Workers' Union, 1970s.

Tamiment Library Poster and Broadside Collection (GRAPHICS 002), Flat File 7, Drawer 1, Tamiment Library and Robert F. Wagner Labor Archives, New York University.

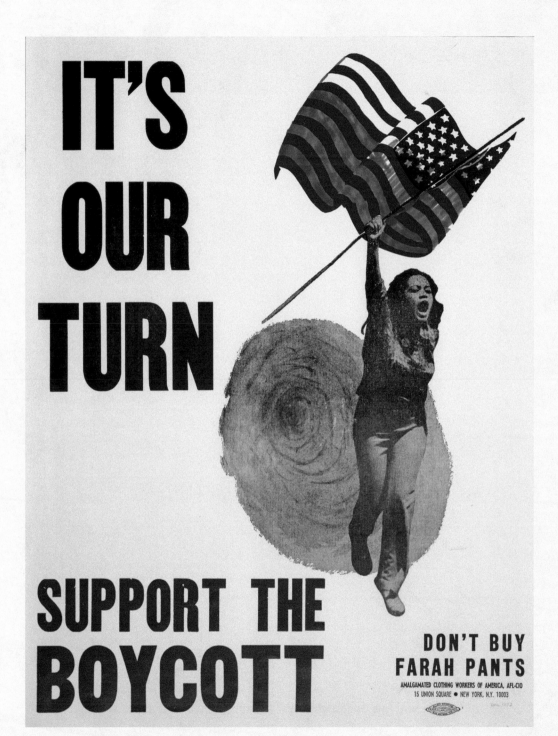

IT'S
OUR
TURN

SUPPORT THE
BOYCOTT

DON'T BUY
FARAH PANTS

AMALGAMATED CLOTHING WORKERS OF AMERICA, AFL-CIO
15 UNION SQUARE ● NEW YORK, N.Y. 10003

Figure 18.

**"My parent is a breadwinner," Independent Federation of Flight
Attendants, 1986.**

Tamiment Library Poster and Broadside Collection (GRAPHICS 002), Flat File 7, Drawer 1,
Tamiment Library and Robert F. Wagner Labor Archives, New York University.

Independent
Federation of
Flight
Attendants

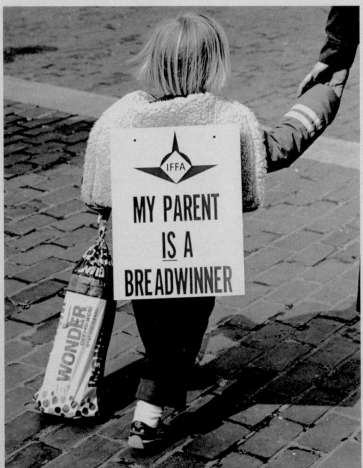

. . . BOYCOTT OF CONSCIENCE
Please Don't Fly TWA

Send Contributions to IFFA Defense Fund 630 3rd Ave. N.Y., N.Y. 10017

Figure 19.

"Fight fire with fire!," American Postal Worker's Union, 1985.

Tamiment Library Poster and Broadside Collection (GRAPHICS 002), Container 1, Container 2, Box 1, Tamiment Library and Robert F. Wagner Labor Archives, New York University.

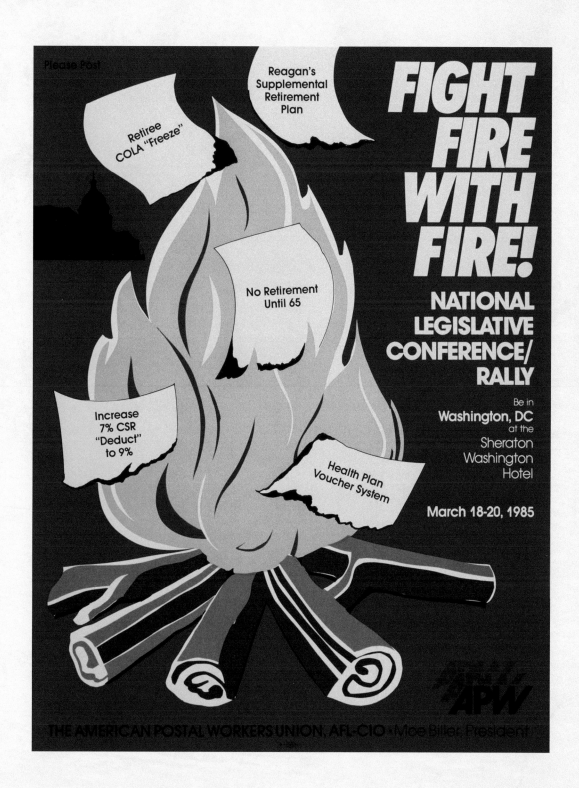

Figure 20.

"Fighting fire with fire," American Postal Worker's Union, mid-1980s.

Tamiment Library Poster and Broadside Collection (GRAPHICS 002), Container 1,
Container 2, Box 1, Tamiment Library and Robert F. Wagner Labor Archives,
New York University.

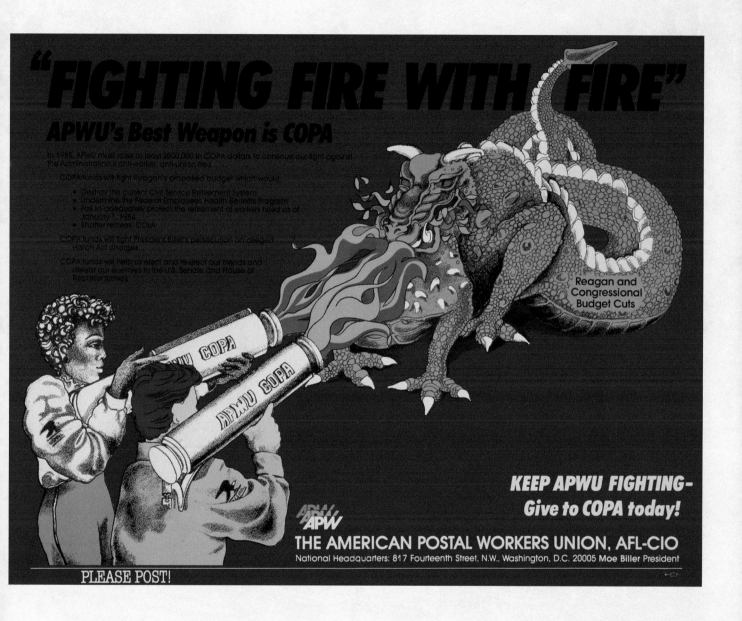

"FIGHTING FIRE WITH "FIRE""

APWU's Best Weapon is COPA

In 1985, APWU must raise at least $800,000 in COPA dollars to continue our fight against the Administration's anti-worker, anti-union fires

COPA funds will fight Reagan's proposed budget which would

- Destroy the current Civil Service Retirement System
- Undermine the Federal Employees Health Benefits Program
- Fail to adequately protect the retirement of workers hired as of January 1, 1984
- Shatter retirees' COLA

COPA funds will fight President Biller's persecution on alleged Hatch Act charges

COPA funds will help us elect and re-elect our friends and defeat our enemies in the U.S. Senate and House of Representatives

Reagan and Congressional Budget Cuts

**KEEP APWU FIGHTING—
Give to COPA today!**

THE AMERICAN POSTAL WORKERS UNION, AFL-CIO

National Headquarters: 817 Fourteenth Street, N.W., Washington, D.C. 20005 Moe Biller President

PLEASE POST!

Figure 21.

"We share the dream," American Postal Worker's Union, 1983.

Tamiment Library Poster and Broadside Collection (GRAPHICS 002), Container 1,
Container 2, Box 1, Tamiment Library and Robert F. Wagner Labor Archives,
New York University.

20th Anniversary
MOBILIZATION FOR
JOBS, PEACE AND FREEDOM

August 27, 1983
Lincoln Memorial,
Washington, DC

WE SHARE THE DREAM

AMERICAN POSTAL WORKERS UNION, AFL-CIO
MOE BILLER, PRESIDENT

Figure 22.

"Consider the alternative," New American Movement, 1970s. The New American Movement was a radical New Left feminist organization founded in 1971 after the breakup of Students for a Democratic Society. In 1983, it merged with another left-wing organization to form the Democratic Socialists of America.

Courtesy Democratic Socialists of America. Tamiment Library Poster and Broadside Collection (GRAPHICS 002), Container 1, Box 2, Tamiment Library and Robert F. Wagner Labor Archives, New York University.

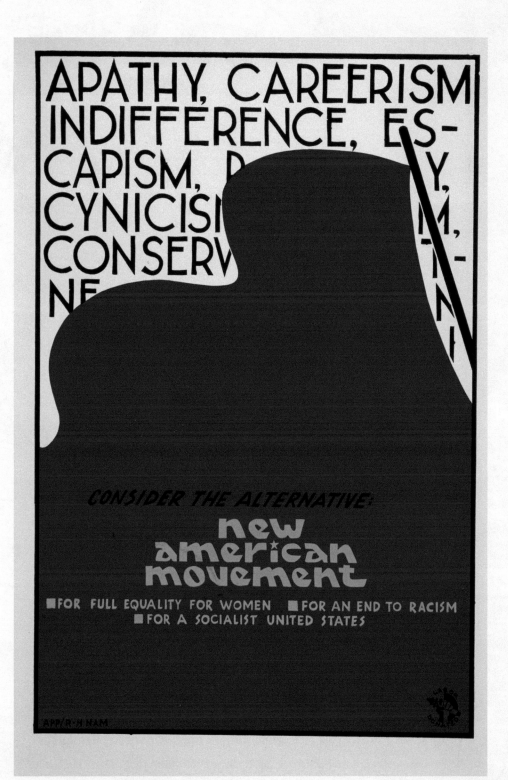

APATHY, CAREERISM
INDIFFERENCE, ES-
CAPISM, R Y,
CYNICIS M,
CONSERV T-
NE N

CONSIDER THE ALTERNATIVE:

new
american
movement

■FOR FULL EQUALITY FOR WOMEN ■FOR AN END TO RACISM
■FOR A SOCIALIST UNITED STATES

APP/R·H NAM

Figure 23.

"Coal operators grow rich while miners die," Miners Art Group, n.d.

Tamiment Library Poster and Broadside Collection (GRAPHICS 002), Box 1, Tamiment Library and Robert F. Wagner Labor Archives, New York University.

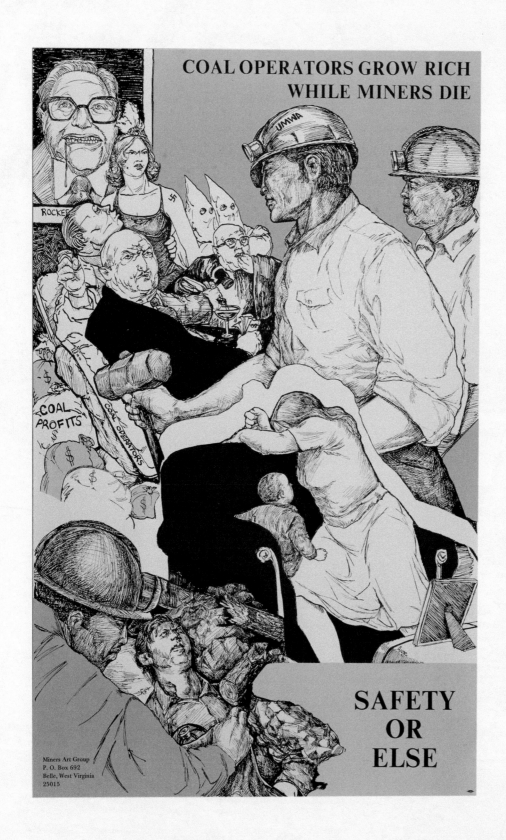

Figure 24.

"We shall overcome," Louis Lo Monaco, 1963. A poster for the March on Washington for Jobs and Freedom.

Tamiment Library Poster and Broadside Collection (GRAPHICS 002), Flat File 7, Drawer 2, Tamiment Library and Robert F. Wagner Labor Archives, New York University.

MARCH ON WASHINGTON FOR JOBS AND FREEDOM AUGUST 28,1963

We Shall

Overcome

lomonaco

Figure 25.

"March on Washington for Jobs and Freedom," artist unknown, 1963.

Tamiment Library Poster and Broadside Collection (GRAPHICS 002), Flat File 7, Drawer 2, Tamiment Library and Robert F. Wagner Labor Archives, New York University.

for jobs

and freedom

MARCH ON WASHINGTON

august 28, 1963

make reservations

BRONX CORE • DAyton 3-8060

$6.50 Round Trip

• buses leave from 169 st. & Boston Road

Figure 26.

"Freedom now," CORE, c. 1963. The poster features the logo for the Congress of Racial Equality.

Tamiment Library Poster and Broadside Collection (GRAPHICS 002), Flat File 7, Drawer 2, Tamiment Library and Robert F. Wagner Labor Archives, New York University.

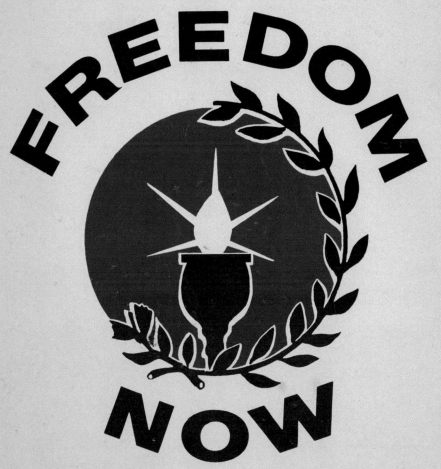

HARLEM! SUPPORT CORE
FOR JOBS + EDUCATION

FREEDOM
NOW

DISPLAY THIS SYMBOL
WITH PRIDE

FREEDOM NOW DRIVE
22 MILLINGUM STREET
MOUNT VERNON, N. Y.
Mount Vernon 8-7146

Figure 27.

"Let's finish the job now," NAACP, 1963. A recruitment poster for the National Association for the Advancement of Colored People.

Tamiment Library Poster and Broadside Collection (GRAPHICS 002), Flat File 7, Drawer 2, Tamiment Library and Robert F. Wagner Labor Archives, New York University.

Figure 28.

"Now," SNCC, probably 1963. March on Washington correspondence, 1962–64. Courtesy Danny Lyon/Magnum Photos.

Tamiment Library Poster and Broadside Collection (GRAPHICS 002), Flat File 7, Drawer 1, Tamiment Library and Robert F. Wagner Labor Archives, New York University.

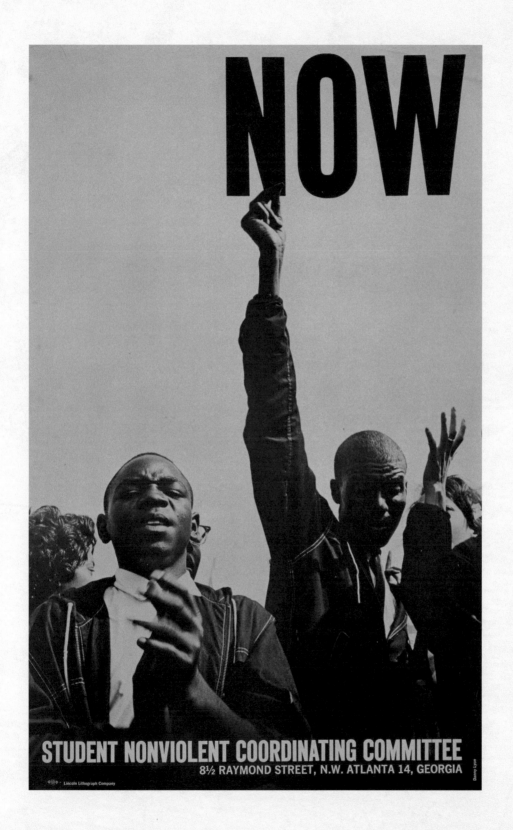

Figure 29.

"One man one vote," SNCC, c. 1964. Miscellaneous tearsheet, 1962–64.
Courtesy Danny Lyon / Magnum Photos.

Tamiment Library Poster and Broadside Collection (GRAPHICS 002), Flat File 7, Drawer 1,
Tamiment Library and Robert F. Wagner Labor Archives, New York University.

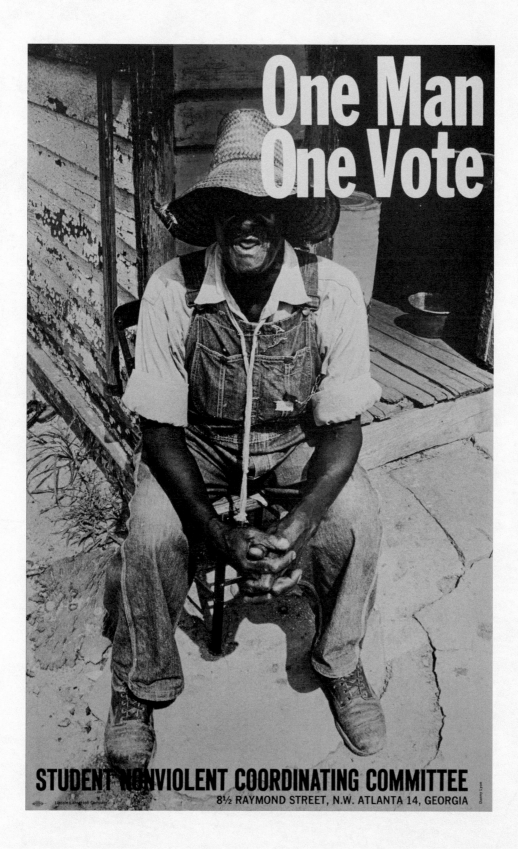

Figure 30.

"Is he protecting you?," SNCC, c. 1964. Image of Mississippi Highway Patrol trooper. Mississippi correspondence, 1962–64. Courtesy Danny Lyon / Magnum Photos.

Tamiment Library Poster and Broadside Collection (GRAPHICS 002), Flat File 7, Drawer 1, Tamiment Library and Robert F. Wagner Labor Archives, New York University.

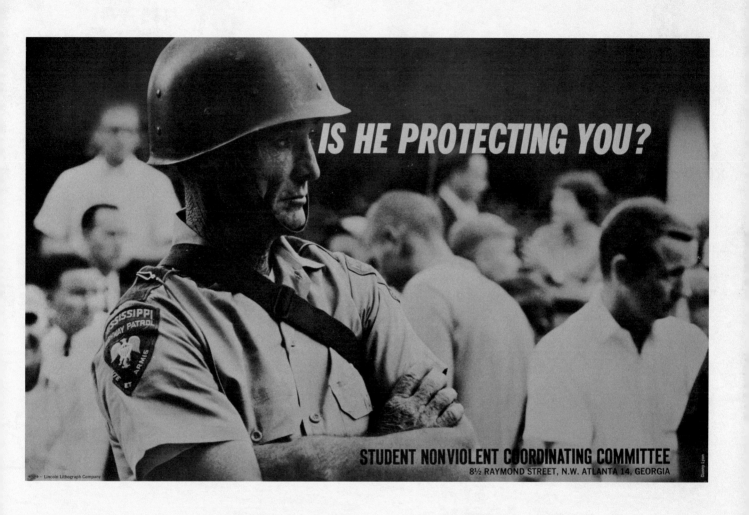

Figure 31.

"Power to the people," Black Panther Party, Committee to Defend the Panther 21, 1970. The Black Panther 21 were members of the Black Panther Party who were arrested in 1969 and charged with planning a coordinated bomb attack on several police stations in New York City. After an eight-month trial they were acquitted. This poster was created to raise funds for their defense.

Tamiment Library Poster and Broadside Collection (GRAPHICS 002), Flat File 7, Drawer 1, Tamiment Library and Robert F. Wagner Labor Archives, New York University.

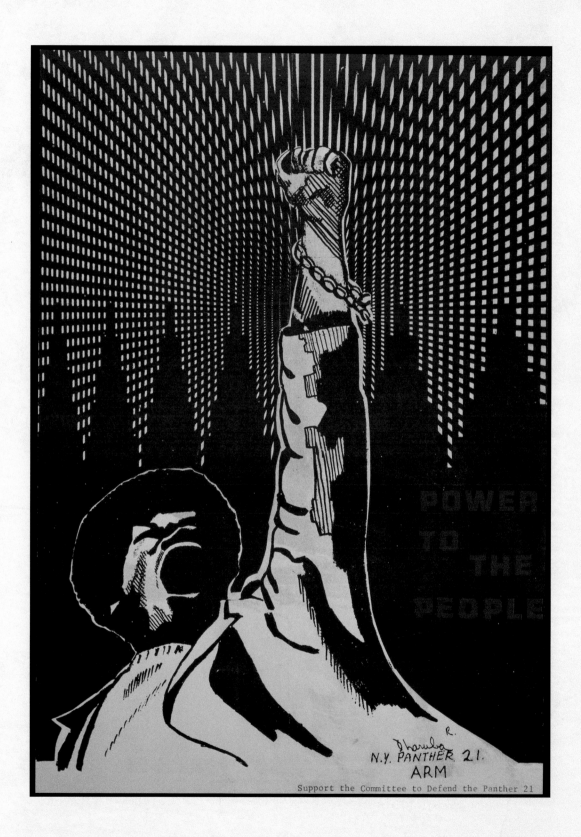

POWER
TO
THE
PEOPLE

Dharuba
N.Y. PANTHER 21.
ARM

Support the Committee to Defend the Panther 21

Figure 32.

"John Brown," Movement Press, n.d.

Tamiment Library Poster and Broadside Collection (GRAPHICS 002), Flat File 7, Drawer 1,
Tamiment Library and Robert F. Wagner Labor Archives, New York University.

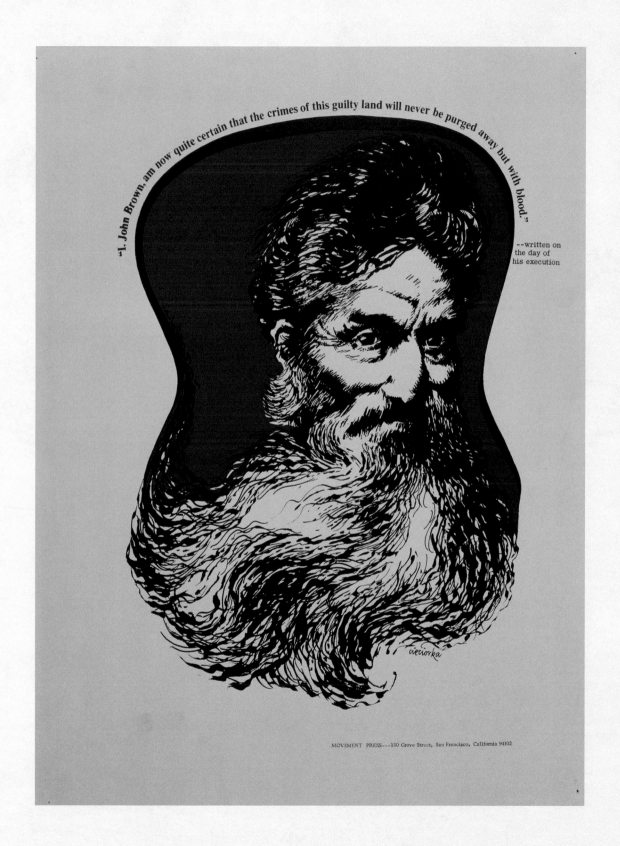

"I, John Brown, am now quite certain that the crimes of this guilty land will never be purged away but with blood."

--written on the day of his execution

MOVEMENT PRESS---330 Grove Street, San Francisco, California 94102

Figure 33.

"By any means necessary," Young Socialist Alliance, 1970s.

Tamiment Library Poster and Broadside Collection (GRAPHICS 002), Flat File 7, Drawer 5, Tamiment Library and Robert F. Wagner Labor Archives, New York University.

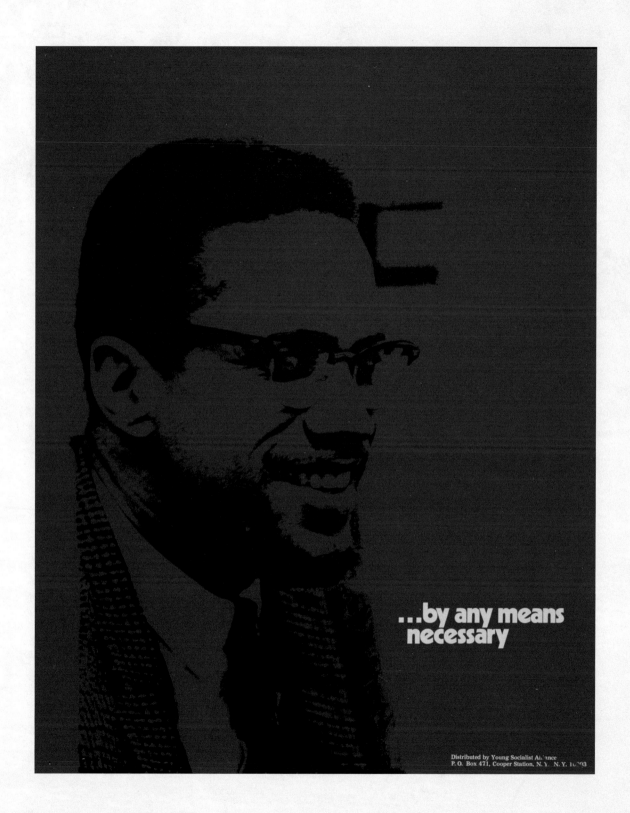

...by any means necessary

Distributed by Young Socialist Alliance
P. O. Box 471, Cooper Station, N. Y. N. Y. 10003

Figure 34.

"Stop killer cops," Baraka Defense Committee, probably 1979. In 1979, the noted African American poet and activist Amiri Baraka was put on trial for allegedly assaulting police officers while resisting arrest. This poster was issued at the time to raise funds for his defense and to protest police brutality.

Tamiment Library Poster and Broadside Collection (GRAPHICS 002), Flat File 7, Drawer 1, Tamiment Library and Robert F. Wagner Labor Archives, New York University.

AFRO-AMERICAN FAMILY
1979, '78, '77, '76

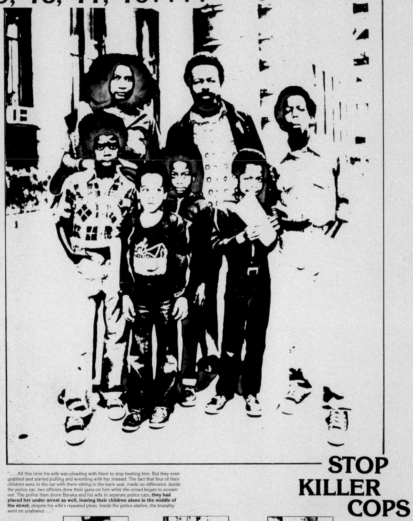

"...All this time his wife was pleading with them to stop beating him. But they even grabbed and started pulling and wrestling with her instead. The fact that four of their children were in the car with them sitting in the back seat, made no difference. Inside the police car, two officers drew their guns on him while the crowd began to scream out. The police then drove Baraka and his wife in separate police cars, **they had placed her under arrest as well, leaving their children alone in the middle of the street,** despite his wife's repeated pleas. Inside the police station, the brutality went on unabated . . ."

STOP
KILLER
COPS

The Barakas with their attorney, Conrad Lynn, speak out against systematic oppression by the police who maintain the interest and control of the corporate elite.

THE PEOPLE UNITED WILL NEVER BE DEFEATED

All oppressed nationalities and poor people are subject to be victims of police brutality. It is only through the unity of the masses that we are able to effectively struggle against police brutality and defend our human rights.

We must build a broad multinational defense committee which will include anyone willing to struggle against police brutality. We must unite irrespective of nationality, religion, age and sex. We must be willing to struggle against national oppression and racism and for democracy of all working people.

BUILD THE BARAKA DEFENSE COMMITTEE!

TRIAL AND RALLY FRIDAY SEPT. 14

Rm. AP17 at 9:30 AM
Criminal Court House
100 Center St. Manhattan

FUNDRAISERS TO BE ANNOUNCED

For more information:
New York (212) 299-3332, 283-2926
New Jersey (201) 242-1346

Figure 35.

"War on the people," L. Mahler, Augusta, Georgia, 1970. A sardonic commentary on police violence that was published more than four decades before the Black Lives Matter movement.

Tamiment Library Poster and Broadside Collection (GRAPHICS 002), Flat File 7, Drawer 1, Tamiment Library and Robert F. Wagner Labor Archives, New York University.

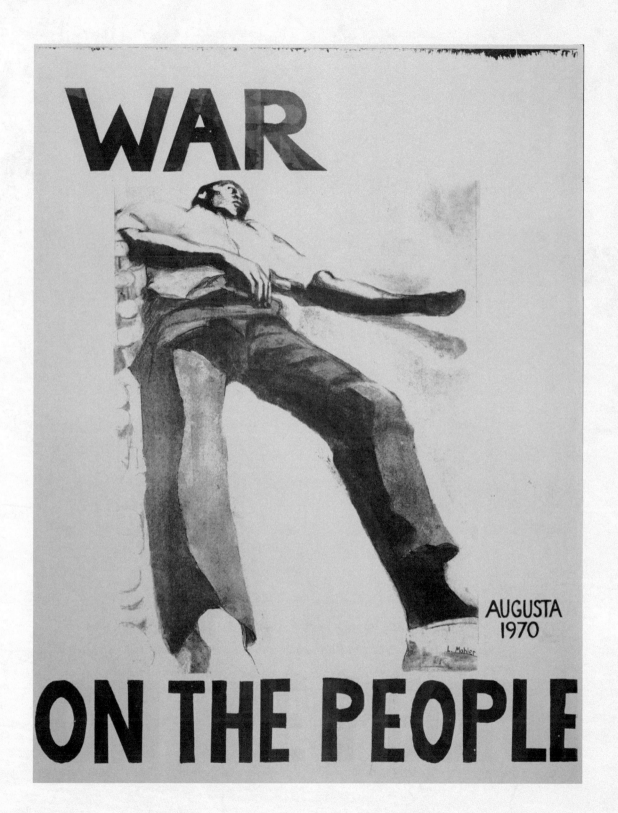

Figure 36.

"He only made page 5," artist unknown, 1970. This poster was published after the Kent State shootings to protest that the killing of four white student protestors was covered on the front page of most newspapers in the country, whereas the killing of six African Americans who were protesting the death of a black man in a Georgia prison "only made page 5."

Tamiment Library Poster and Broadside Collection (GRAPHICS 002), Container 1, Box 2, Tamiment Library and Robert F. Wagner Labor Archives, New York University.

AUGUSTA

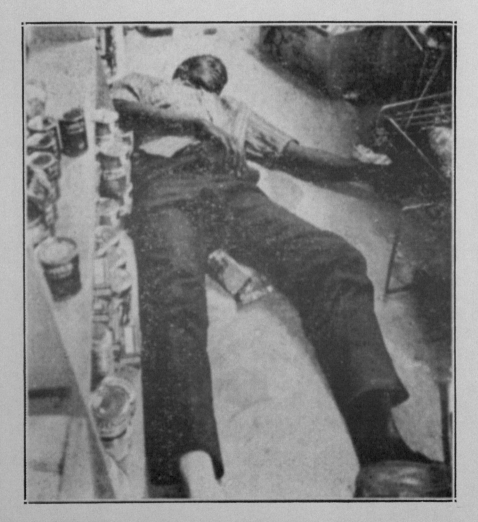

HE ONLY MADE PAGE 5

Figure 37.

"Hot town," Michael James, 1968. A Students for a Democratic Society poster to drum up support for the "Days of Rage" protests.

Tamiment Library Poster and Broadside Collection (GRAPHICS 002), Flat File 7, Drawer 5, Tamiment Library and Robert F. Wagner Labor Archives, New York University.

HOT TOWN — PIGS IN THE STREETS . . .

BUT THE STREETS BELONG TO THE PEOPLE !

DIG IT ?

Sunshine Jubilee

Figure 38.

"Up ag-ag-against th-th-the wall," artist unknown, c. 1969. Another wry commentary on police tactics.

Tamiment Library Poster and Broadside Collection (GRAPHICS 002), Flat File 7, Drawer 5, Tamiment Library and Robert F. Wagner Labor Archives, New York University.

Up ag-ag-against th-th-the wall, M-Motherf-f-fu-fu-fv

Figure 39.

"Malcolm X, Ho Chi Minh," Jerry Biggs, c. 1980. A poster celebrating the May 19 birthdays of two heroes of the radical left.

Tamiment Library Poster and Broadside Collection (GRAPHICS 002), Flat File 7, Drawer 1, Tamiment Library and Robert F. Wagner Labor Archives, New York University.

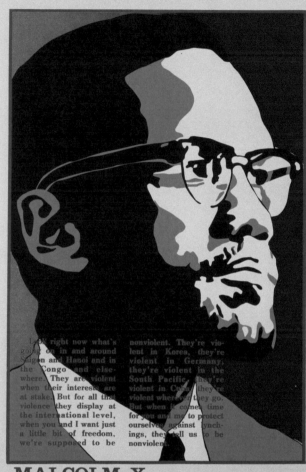

...ly right now what's
going on in and around
Saigon and Hanoi and in
the Congo and else-
where. They are violent
when their interests are
at stake. But for all that
violence they display at
the international level,
when you and I want just
a little bit of freedom,
we're supposed to be

nonviolent. They're vio-
lent in Korea, they're
violent in Germany,
they're violent in the
South Pacific, they're
violent in China, they're
violent wherever they go.
But when it comes time
for you and me to protect
ourselves against lynch-
ings, they tell us to be
nonviolent.

MALCOLM X
born: May 19, 1925

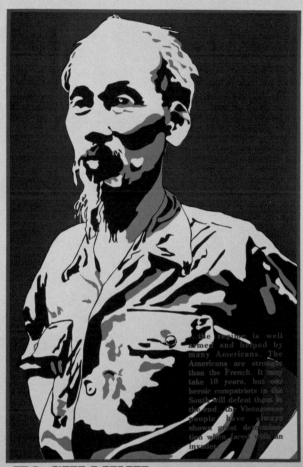

...the regime is well
armed and helped by
many Americans. The
Americans are stronger
than the French. It may
take 10 years, but our
heroic compatriots in the
South will defeat them in
the end. The Vietnamese
people have always
shown great determina-
tion when faced with an
invader...

HO CHI MINH
born: May 19, 1890

Figure 40.

"What makes the difference?," Red Tide, mid-1970s. Red Tide was a radical high school newspaper and organization from 1971 to 1981 that opposed the war in Vietnam and supported the struggles of African Americans, the American Indian Movement, and other minorities. This poster was one of those Red Tide published condemning apartheid. Courtesy Michael Letwin.

Tamiment Library Poster and Broadside Collection (GRAPHICS 002), Flat File 7, Drawer 8, Tamiment Library and Robert F. Wagner Labor Archives, New York University.

This miner makes $7/hr. This miner makes 54¢/hr.

USA **SOUTH AFRICA**

WHAT MAKES THE DIFFERENCE?
ANSWER: U.S. MONEY.

Not the money US corporations give to this American miner. They don't give him any. He has to strike for every cent. . . .

. . . But the $3 billion US corporations invest in South Africa. This lets South Africa spend $300 million a year on the military to keep black Africans down.

IF YOU THINK THAT AMERICAN FOREIGN AID AND INVESTMENTS HELP THE PEOPLE OF POORER NATIONS — THINK AGAIN. IN SOUTH AFRICA, IT'S THE OPPOSITE.

Workers' Power Red Tide 14131 Woodward Highland Park M 4820

Figure 41.

"End apartheid," Lincoln Cushing, 1985.

Tamiment Library Poster and Broadside Collection (GRAPHICS 002), Flat File 7, Drawer 8,
Tamiment Library and Robert F. Wagner Labor Archives, New York University.

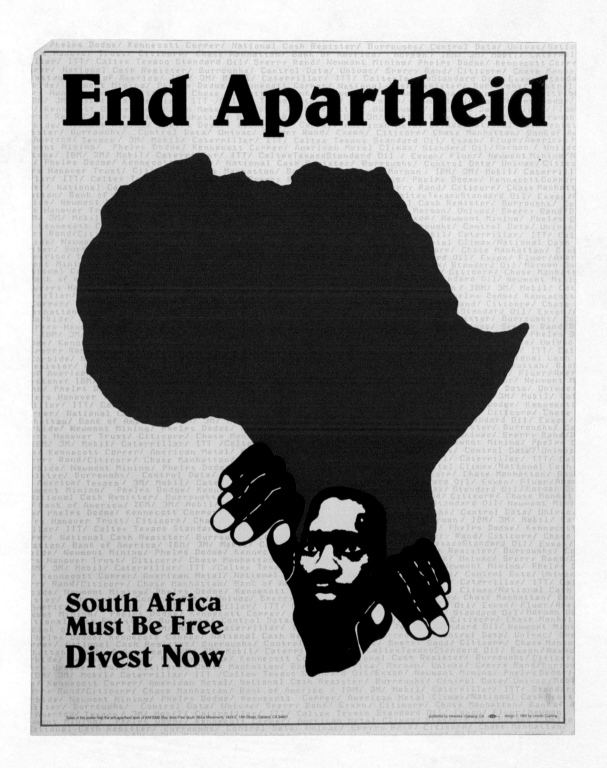

End Apartheid

South Africa Must Be Free Divest Now

Sales of this poster help the anti-apartheid work of BAFSAM (Bay Area Free South Africa Movement), 5424 E. 14th Street, Oakland, CA 94601. published by Inkworks—Oakland, CA design © 1985 by Lincoln Cushing

Figure 42.

"Smash apartheid!," Red Tide, mid-1970s. Another antiapartheid poster from Red Tide. Courtesy Michael Letwin.

Tamiment Library Poster and Broadside Collection (GRAPHICS 002), Flat File 7, Drawer 8, Tamiment Library and Robert F. Wagner Labor Archives, New York University.

VICTORY TO THE SOUTH AFRICAN REVOLUTION

SMASH APARTHEID!

Workers' Power

14131 Woodward Avenue, Highland Park, Michigan 48203

SUN DISTRIBUTION INTERNATIONAL

Figure 43.

"The struggle is my life," from the cover of Nelson Mandela's book
***The Struggle Is My Life*, 1978. Courtesy Pathfinder Press.**

Tamiment Library Poster and Broadside Collection (GRAPHICS 002), Flat File 7, Drawer 5,
Tamiment Library and Robert F. Wagner Labor Archives, New York University.

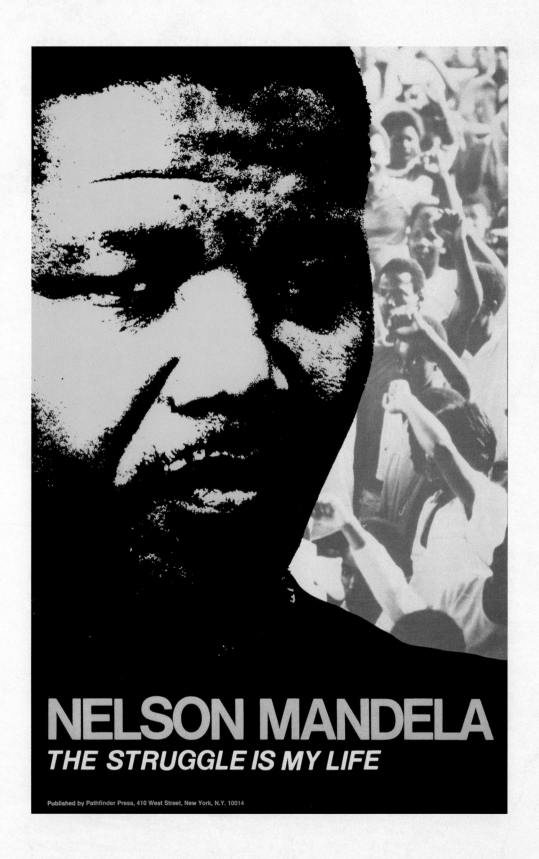

NELSON MANDELA
THE STRUGGLE IS MY LIFE

Published by Pathfinder Press, 410 West Street, New York, N.Y. 10014

Figure 44.

**Poster by the political activist and graphic artist Carlos A. Cortéz,
Industrial Workers of the World, c. 1970. This image of an older
couple weeping over a casket is a statement against the Vietnam War.
Cortéz was also a conscientious objector during World War II.**

Tamiment Library Poster and Broadside Collection (GRAPHICS 002), Flat File 7, Drawer 2,
Tamiment Library and Robert F. Wagner Labor Archives, New York University.

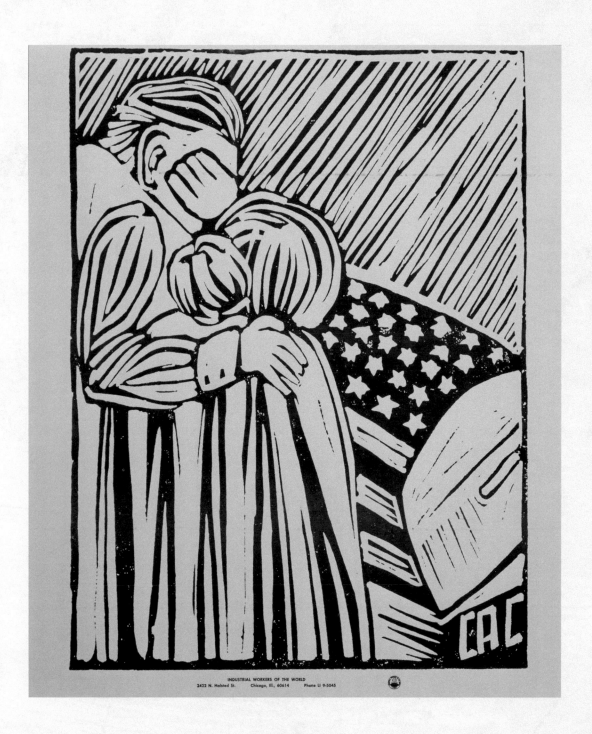

INDUSTRIAL WORKERS OF THE WORLD
2422 N. Halsted St. Chicago, Ill., 60614 Phone LI 9-5045

Figure 45.

"Greetings," Carlos A. Cortéz, Industrial Workers of the World, 1965. This image and figure 46 have also been combined into a single antidraft poster.

Tamiment Library Poster and Broadside Collection (GRAPHICS 002), Flat File 7, Drawer 2, Tamiment Library and Robert F. Wagner Labor Archives, New York University.

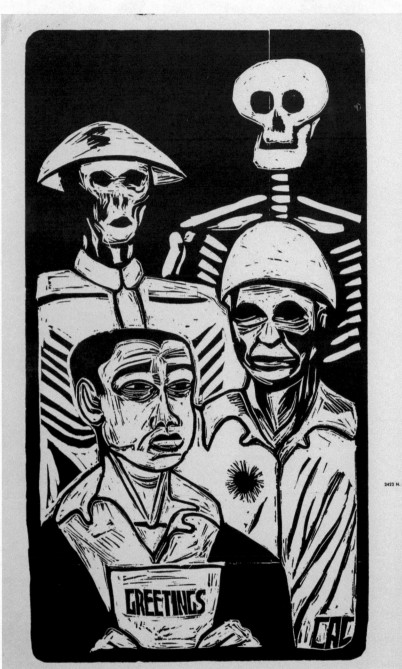

INDUSTRIAL WORKERS OF THE WORLD
2422 N. Halsted St. Chicago, Ill., 60614 Phone LI 9-5045

Figure 46.

"Draftees of the world, unite!," Carlos A. Cortéz, Industrial Workers of the World, 1965.

Tamiment Library Poster and Broadside Collection (GRAPHICS 002), Flat File 7, Drawer 2, Tamiment Library and Robert F. Wagner Labor Archives, New York University.

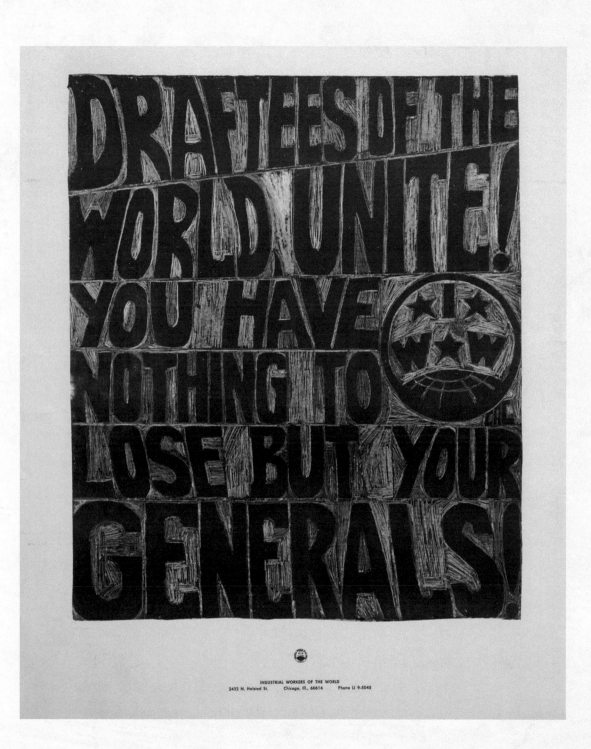

Figure 47.

"1967, 1968, 1969," artist unknown, 1970. This antiwar poster underscores the escalation of the antiwar movement into a more militant force.

Tamiment Library Poster and Broadside Collection (GRAPHICS 002), Container 1, Box 2, Tamiment Library and Robert F. Wagner Labor Archives, New York University.

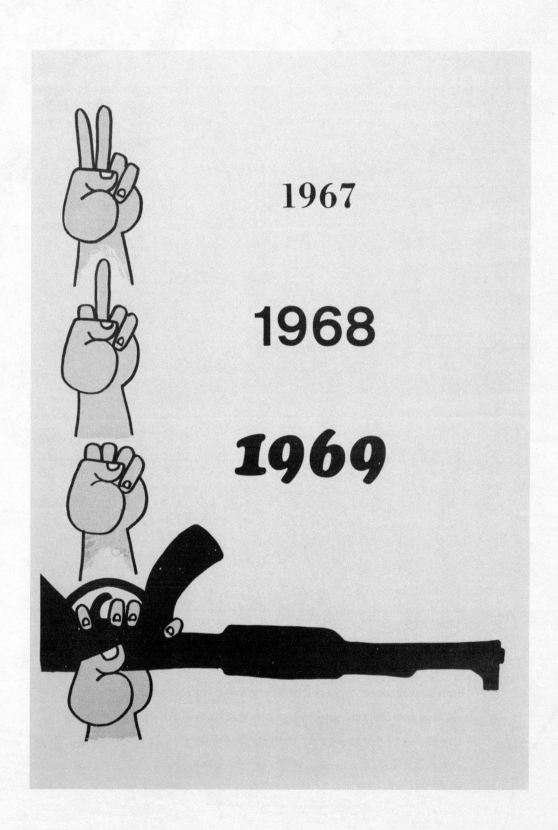

1967

1968

1969

Figure 48.

"This power has become the aggressor," Black Workers Congress, c. 1971. The Black Workers Congress was a militant Marxist organization that focused on black liberation and anti-imperialism. The quote is from the African nationalist Amílcar Cabral who fought for the liberation of Portugal's African colonies. He was assassinated in 1973.

Tamiment Library Poster and Broadside Collection (GRAPHICS 002), Flat File 7, Drawer 4, Tamiment Library and Robert F. Wagner Labor Archives, New York University.

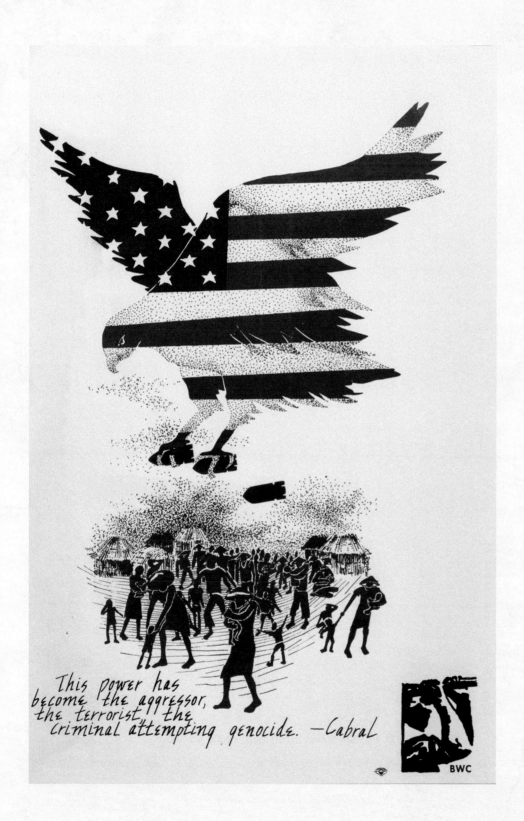

This power has become the aggressor, the terrorist, the criminal attempting genocide. —Cabral

BWC

Figure 49.

"Stop the war now," artist unknown, early 1970s.

Tamiment Library Poster and Broadside Collection (GRAPHICS 002), Container 1, Box 2, Tamiment Library and Robert F. Wagner Labor Archives, New York University.

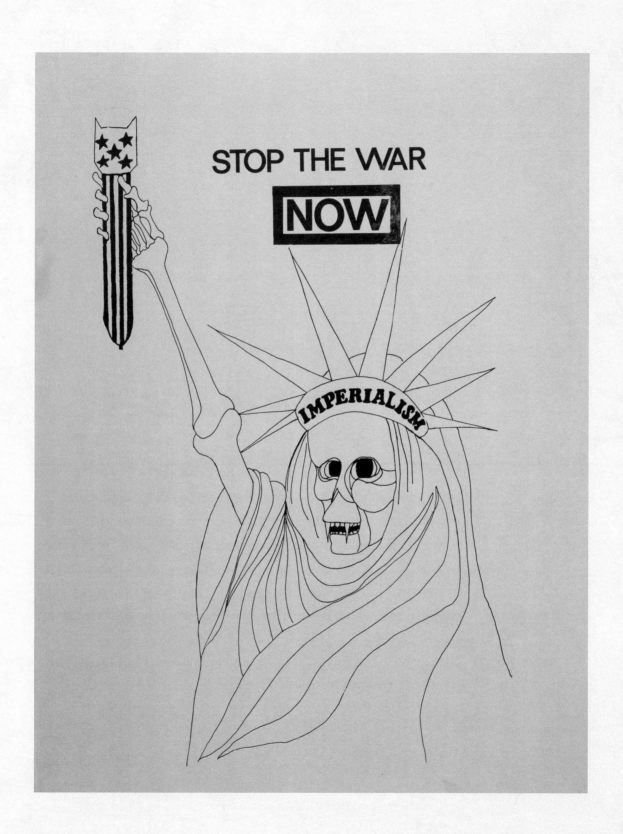

Figure 50.

Poster by the Chicago Women's Graphics Collective, early 1970s. The Chicago Women's Graphics Collective was founded by the Chicago Women's Liberation Union in 1970. The group's mission was to bring women artists together to design and produce silkscreen posters. The goal was to break from the male tradition of autonomous individual artists by working collectively and thereby to act as a force for the liberation of women artists. Courtesy of the CWLU Herstory Project, www.cwluherstory.org.

Tamiment Library Poster and Broadside Collection (GRAPHICS 002), Flat File 7, Drawer 4, Tamiment Library and Robert F. Wagner Labor Archives, New York University.

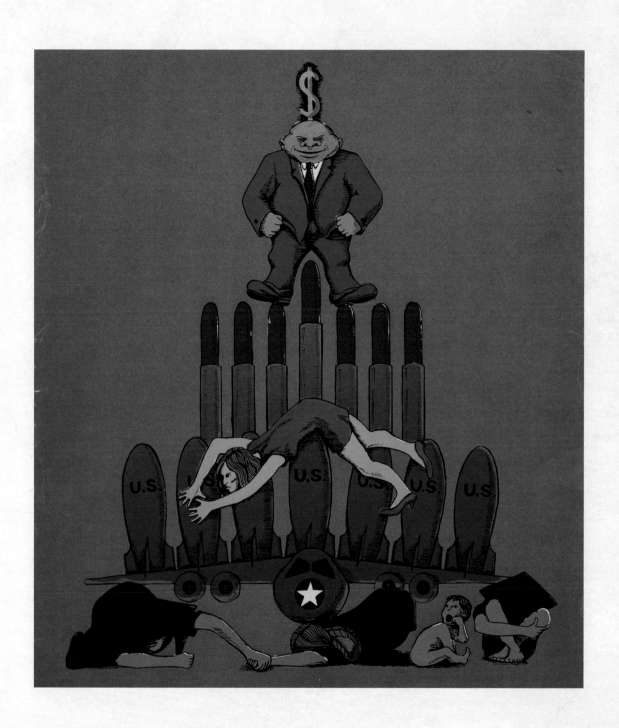

Figure 51.

"Imperialist war and male chauvinism," Chicago Women's Graphics Collective, early 1970s. Courtesy of the CWLU Herstory Project, www.cwluherstory.org.

Tamiment Library Poster and Broadside Collection (GRAPHICS 002), Flat File 7, Drawer 4, Tamiment Library and Robert F. Wagner Labor Archives, New York University.

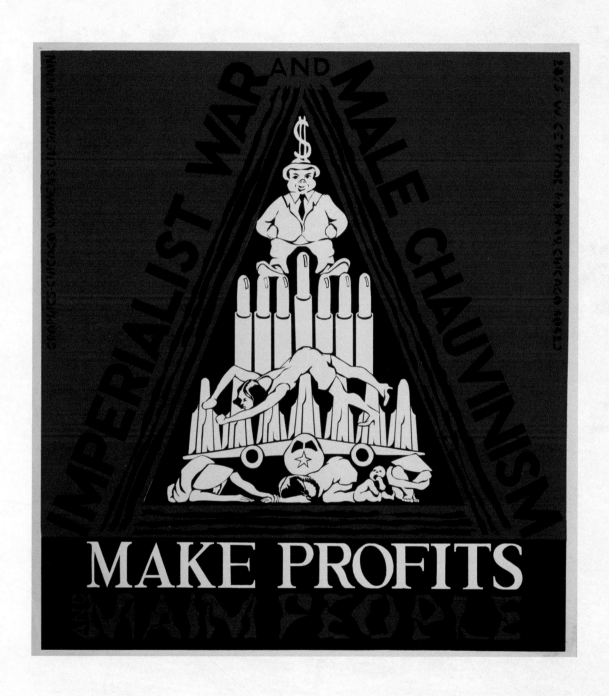

Figure 52.

"A certain shepherd oppressed the sheep," Solidarity Bookshop, early 1970s.

Tamiment Library Poster and Broadside Collection (GRAPHICS 002), Flat File 7, Drawer 4, Tamiment Library and Robert F. Wagner Labor Archives, New York University.

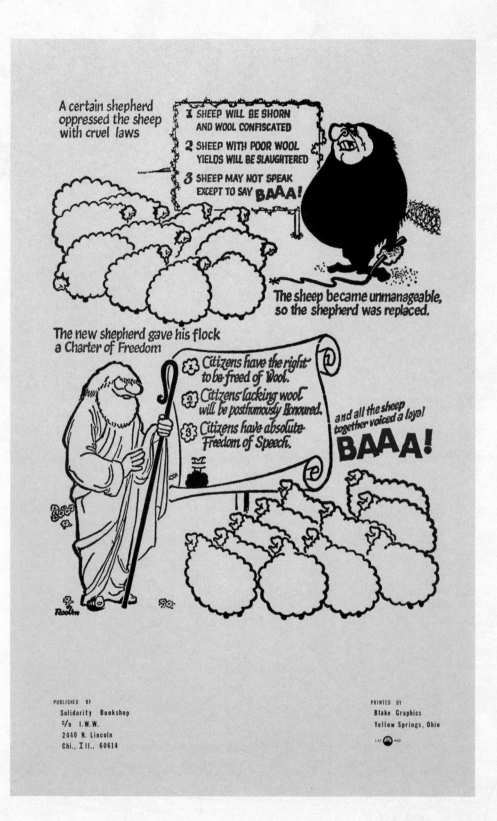

PUBLISHED BY
Solidarity Bookshop
c/o I.W.W.
2440 N. Lincoln
Chi., Ill., 60614

PRINTED BY
Blake Graphics
Yellow Springs, Ohio

Figure 53.

"Make your own world," Woodstock Anarchist Party, early 1970s.

Tamiment Library Poster and Broadside Collection (GRAPHICS 002), Flat File 7, Drawer 4,
Tamiment Library and Robert F. Wagner Labor Archives, New York University.

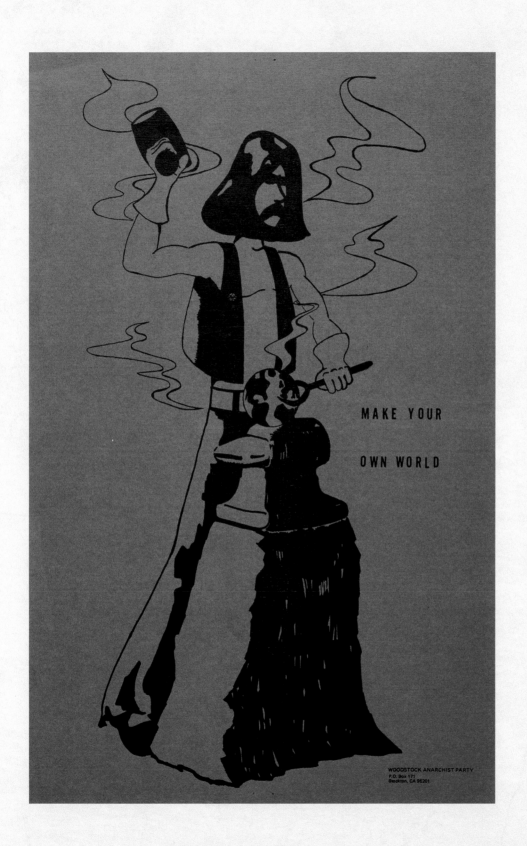

MAKE YOUR

OWN WORLD

WOODSTOCK ANARCHIST PARTY
P.O. Box 171
Stockton, CA 95201

Figure 54.

"Fuck authority," *Fifth Estate*, **1975. The** *Fifth Estate* **is an antiauthoritarian, anticapitalist, anarchist magazine founded in 1965.**

Tamiment Library Poster and Broadside Collection (GRAPHICS 002), Flat File 7, Drawer 4, Tamiment Library and Robert F. Wagner Labor Archives, New York University.

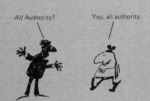

Figure 55.

"The elections don't mean shit," Students for a Democratic Society, c. 1968.

Tamiment Library Poster and Broadside Collection (GRAPHICS 002), Container 1, Box 2,
Tamiment Library and Robert F. Wagner Labor Archives, New York University.

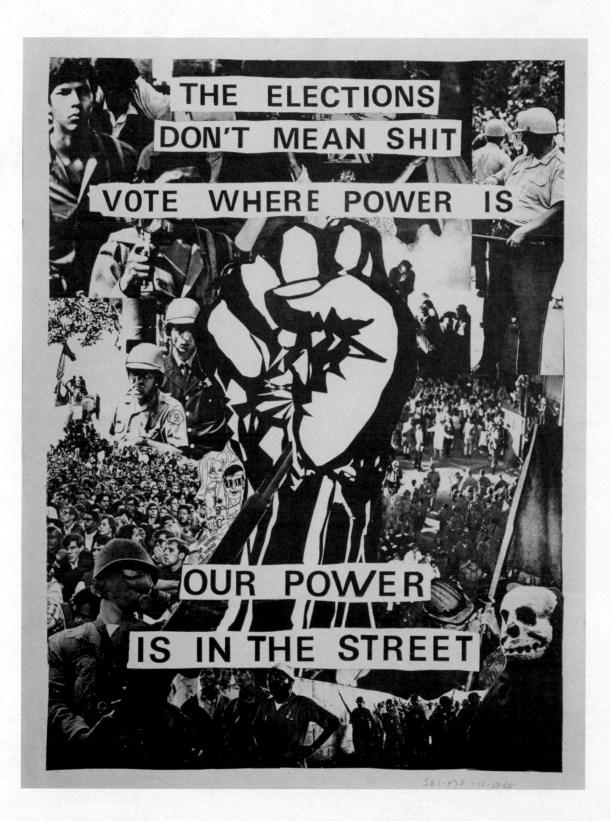

Figure 56.

"It can't happen here," Association of Student Governments, 1971.

Tamiment Library Poster and Broadside Collection (GRAPHICS 002), Flat File 7, Drawer 5, Tamiment Library and Robert F. Wagner Labor Archives, New York University.

IT CAN'T HAPPEN HERE

EMERGENCY CONFERENCE FOR NEW VOTERS

DEC. 3, 4, 5 LOYOLA UNIV., CHICAGO, ILL. Write or Call:
ASG, 2000 P St., N.W.
Washington, D.C. 20036
202—466-8750

Figure 57.

"The nomination day," Miami Conventions Coalition, 1972.

Tamiment Library Poster and Broadside Collection (GRAPHICS 002), Flat File 7, Drawer 5, Tamiment Library and Robert F. Wagner Labor Archives, New York University.

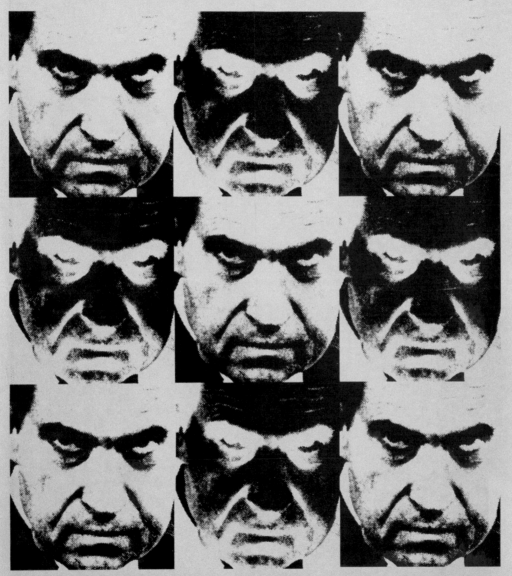

Figure 58.

"Our master's voice," artist unknown, c. 1972.

Tamiment Library Poster and Broadside Collection (GRAPHICS 002), Flat File 7, Drawer 5, Tamiment Library and Robert F. Wagner Labor Archives, New York University.

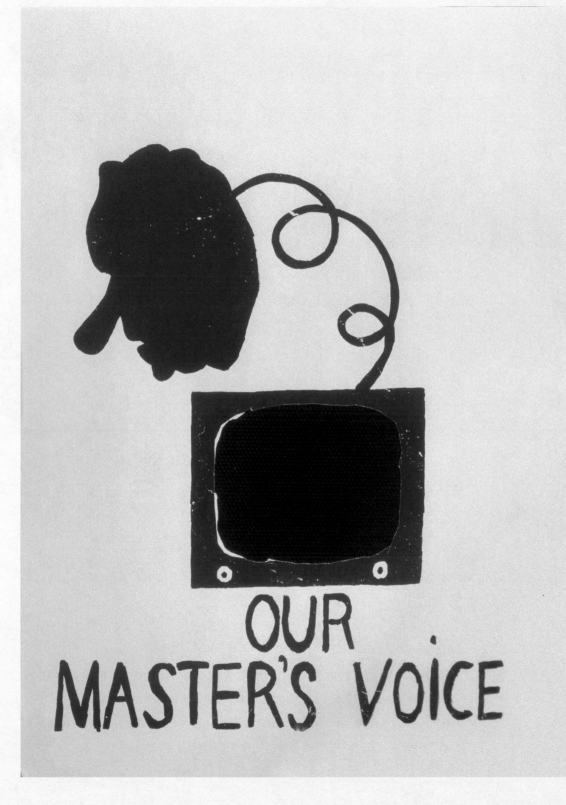

Figure 59.

"Tyrannus Nix?," [Joe?] Kohl, 1970. *Tyrannus Nix?* is the title of a 1969 book by the beat poet and bookseller Lawrence Ferlinghetti.

Tamiment Library Poster and Broadside Collection (GRAPHICS 002), Flat File 7, Drawer 5, Tamiment Library and Robert F. Wagner Labor Archives, New York University.

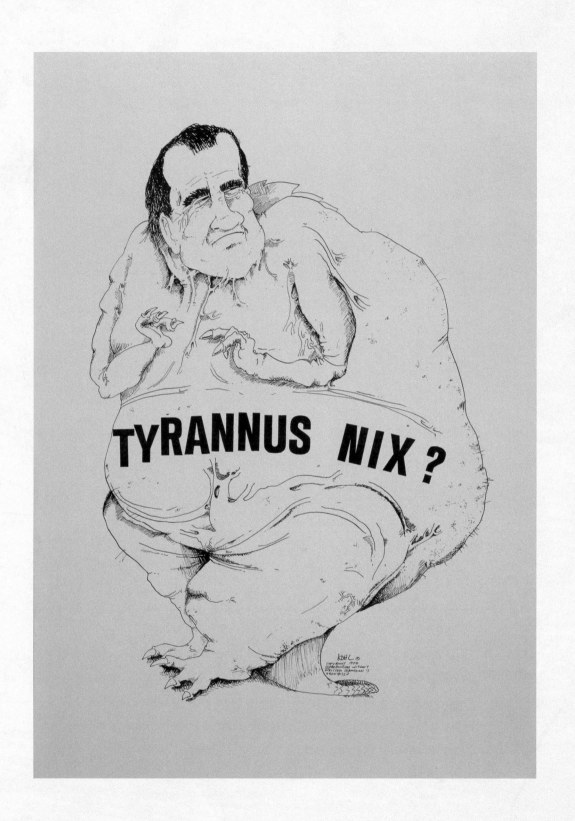

Figure 60.

"GIs united against the war," GI Civil Liberties Defense Committee, 1968. The GIs depicted here are the "Fort Jackson 8," who were arrested for protesting the Vietnam War. The GI Civil Liberties Defense Committee distributed this poster to raise contributions for the defense of the soldiers.

Tamiment Library Poster and Broadside Collection (GRAPHICS 002), Flat File 7, Drawer 1, Tamiment Library and Robert F. Wagner Labor Archives, New York University.

GIs United
Against the War.
Ft. Jackson.

Fighting men.

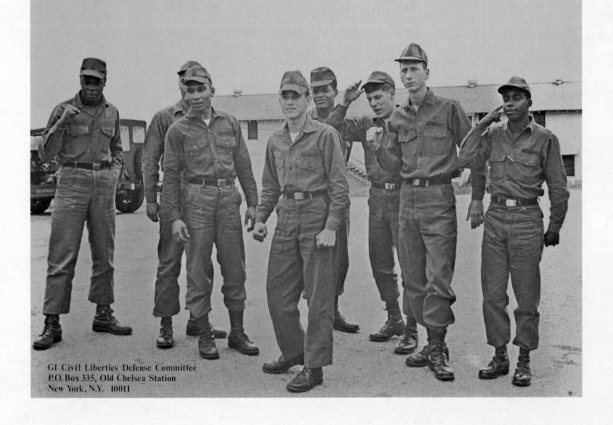

GI Civil Liberties Defense Committee
P.O. Box 335, Old Chelsea Station
New York, N.Y. 10011

Figure 61.

"If we decide ourselves for peace, we will have peace," Kathryn Shagas for the Union of Concerned Scientists, n.d. The Union of Concerned Scientists was founded in 1969 to critically evaluate governmental policies that intersect with the environment and science and technology.

Tamiment Library Poster and Broadside Collection (GRAPHICS 002), Flat File 7, Drawer 4, Tamiment Library and Robert F. Wagner Labor Archives, New York University.

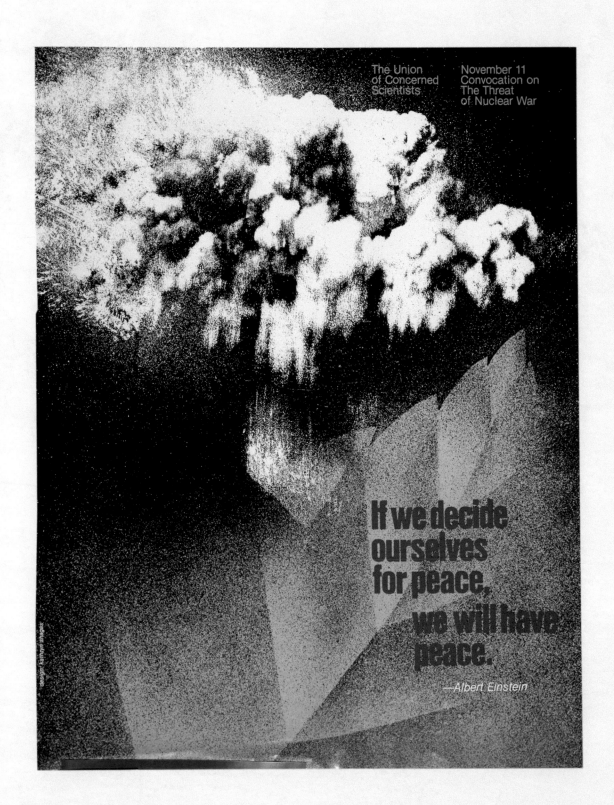

The Union
of Concerned
Scientists

November 11
Convocation on
The Threat
of Nuclear War

If we decide
ourselves
for peace,

we will have
peace.

—*Albert Einstein*

Figure 62.

"It will be a great day," Women's International League for Peace and Freedom, 1979.

Tamiment Library Poster and Broadside Collection (GRAPHICS 002), Flat File 7, Drawer 4, Tamiment Library and Robert F. Wagner Labor Archives, New York University.

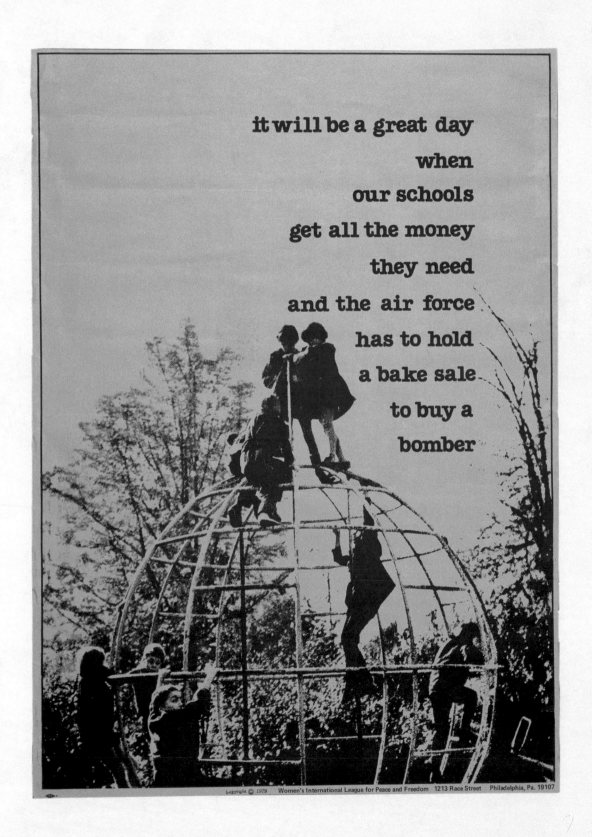

Figure 63.

"There are but two sides in a war," Pan-African Liberation Committee, probably 1972 or 1973.

Tamiment Library Poster and Broadside Collection (GRAPHICS 002), Flat File 7, Drawer 1, Tamiment Library and Robert F. Wagner Labor Archives, New York University.

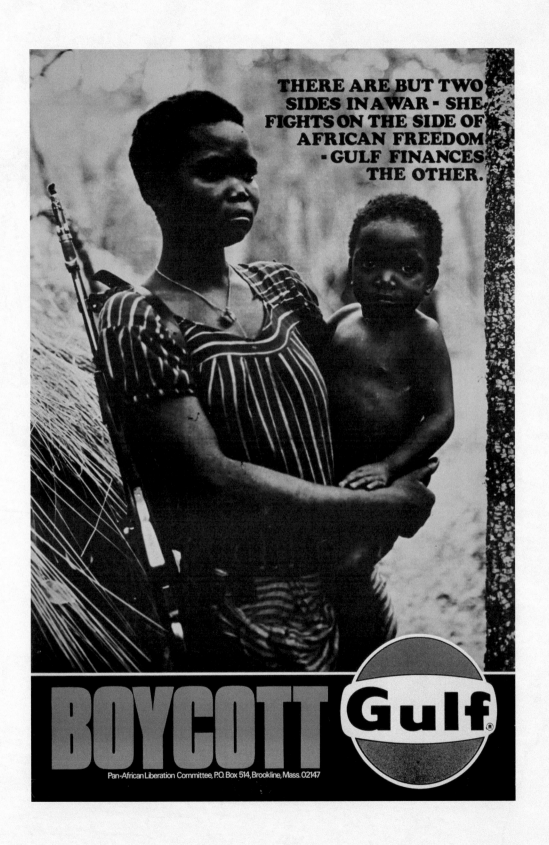

THERE ARE BUT TWO SIDES IN A WAR - SHE FIGHTS ON THE SIDE OF AFRICAN FREEDOM - GULF FINANCES THE OTHER.

BOYCOTT Gulf®

Pan-African Liberation Committee, P.O. Box 514, Brookline, Mass. 02147

Figure 64.

"Iran to the Contras," Nicaragua Solidarity Network of Greater New York, 1987. A satirical poster protesting Reagan's illicit support of the Contras in their effort to overthrow the Sandinista regime in Nicaragua.

Tamiment Library Poster and Broadside Collection (GRAPHICS 002), Flat File 7, Drawer 4, Tamiment Library and Robert F. Wagner Labor Archives, New York University.

The blockbuster film of the 80s

I RAN TO THE CONTRAS

STARRING RONALD **REAGAN**

The story they said was too bizarre to be true, too scary to be told

HE WANTED TO OVERTHROW A SMALL GOVERNMENT, BUT SUBVERTED A BIG ONE— HIS OWN

A cowboy turned outlaw, he wrapped himself in the American flag and left a trail of drugs, murder, and secret bank accounts. Savaging the poor at home wasn't enough; he had to burn schools and clinics in Nicaragua.

From the man who brought you Star Wars, Record Budget Deficits, and dozens of other spectaculars— all with *your* money.

NICARAGUA SUPPORT PROJECT 339 Lafayette Street New York City 10012 / Three to Make Ready Graphics 1987 PRINTED BY RAGGED EDGE PRESS

Figure 65.

"Nearly 50% of your tax dollars go for Reagan's military budget,"
Herb Perr and Irving Wexler for Political Art Documentation &
Distribution, 1981.

Tamiment Library Poster and Broadside Collection (GRAPHICS 002), Flat File 7, Drawer 5,
Tamiment Library and Robert F. Wagner Labor Archives, New York University.

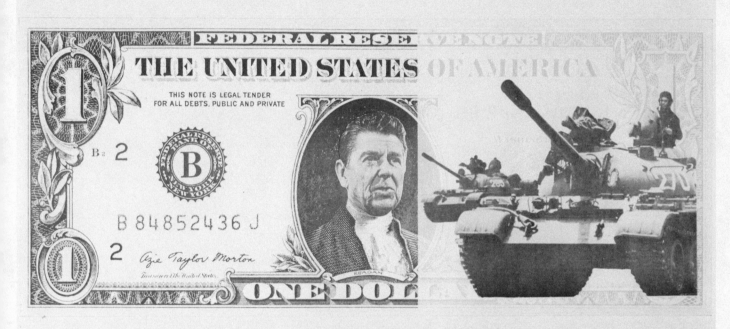

NEARLY 50% OF YOUR TAX DOLLARS GO FOR REAGAN'S MILITARY BUDGET

Figure 66.

"No celebration of a massacre!," Stop the U.S. War Machine Action Network, 1991.

Tamiment Library Poster and Broadside Collection (GRAPHICS 002), Box OS 003, Tamiment Library and Robert F. Wagner Labor Archives, New York University.

NO CELEBRATION OF A MASSACRE! DOWN WITH THE PARADE OF SHAME!

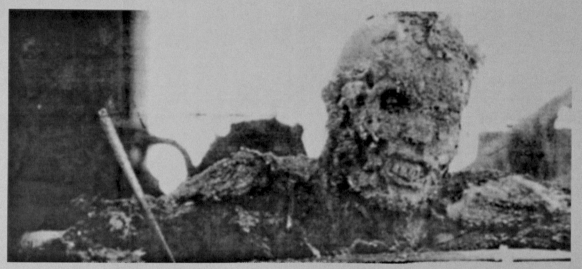

Iraqi soldier turned to ashes after being incinerated by a U.S. bomb, during attack on retreating Iraqi forces fleeing Kuwait. Published in the *London Observer*, 3/10/91 (one of many photographs censored by the U.S. media for showing the real horror of the Gulf War.)

Assemble With The Red and Black: E. Side of Broadway at Ann Street–9:30 A.M.

JUNE 10TH, NYC–THE WHOLE WORLD IS WATCHING.

Stop The U.S. War Machine Action Network, (212) 642-5288

Figure 67.

"Uncle George wants you to forget," Stephen Kroninger, 1991. This critique of George H. W. Bush's prosecution of the Gulf War and neglect of the critical issues facing the nation was originally published in the *Village Voice* and later widely distributed as a poster.

Tamiment Library Poster and Broadside Collection (GRAPHICS 002), Box OS 003, Tamiment Library and Robert F. Wagner Labor Archives, New York University.

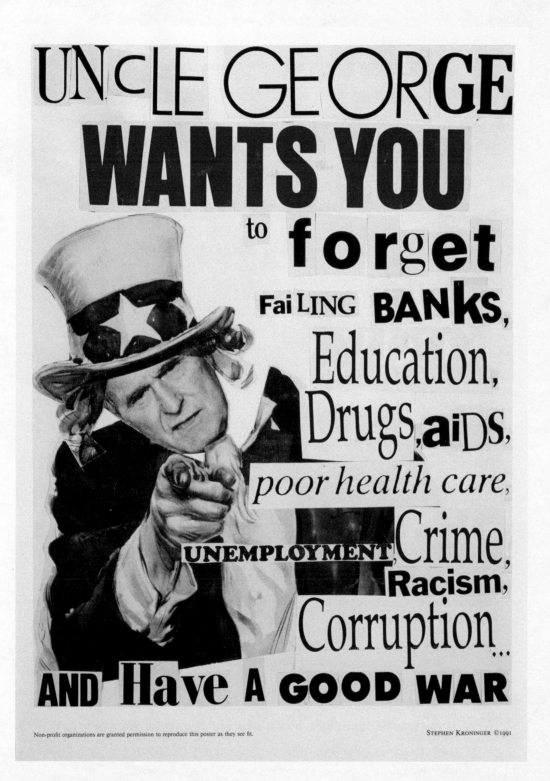

Non-profit organizations are granted permission to reproduce this poster as they see fit. STEPHEN KRONINGER ©1991

Figure 68.

"If you want it done right, hire a woman," Humboldt Women in Art, 1973.

Tamiment Library Poster and Broadside Collection (GRAPHICS 002), Flat File 7, Drawer 3,
Tamiment Library and Robert F. Wagner Labor Archives, New York University.

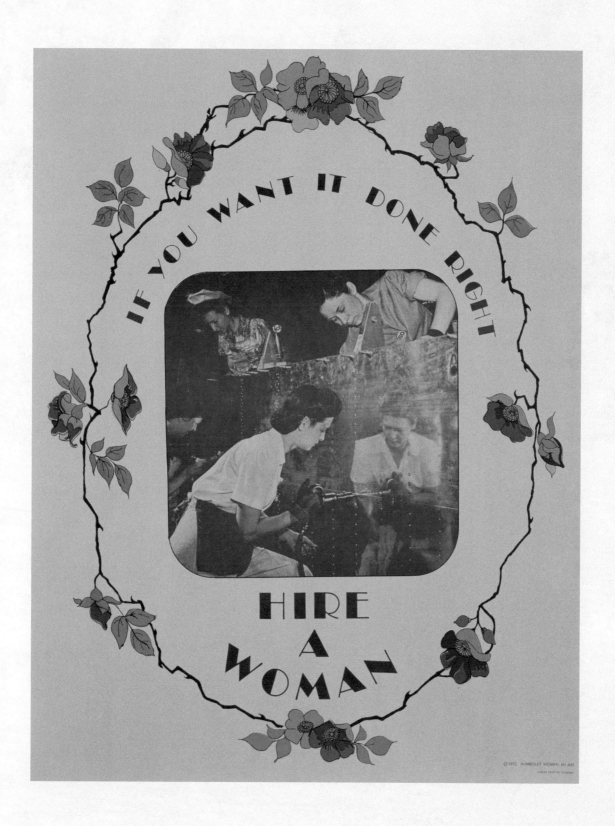

Figure 69.

"Union women build the future," Lincoln Cushing for the Coalition of Labor Union Women, 1986.

Tamiment Library Poster and Broadside Collection (GRAPHICS 002), Container 1, Box 1, Tamiment Library and Robert F. Wagner Labor Archives, New York University.

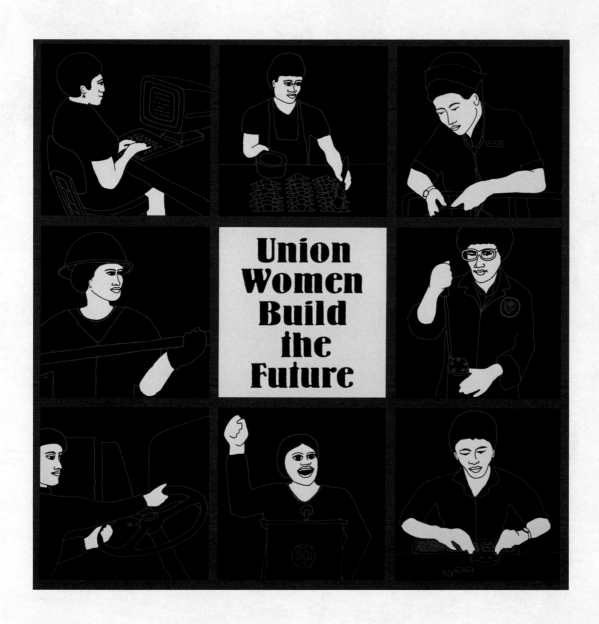

Figure 70.

"Harriet Tubman lives!," artist unknown, n.d.

Tamiment Library Poster and Broadside Collection (GRAPHICS 002), Flat File 7, Drawer 3, Tamiment Library and Robert F. Wagner Labor Archives, New York University.

HARRIET **TUBMAN** *lives!*

Figure 71.

"Working women unite," Chicago Women's Graphics Collective, 1975. Courtesy of the CWLU Herstory Project, www.cwluherstory.org.

Tamiment Library Poster and Broadside Collection (GRAPHICS 002), Flat File 7, Drawer 3, Tamiment Library and Robert F. Wagner Labor Archives, New York University.

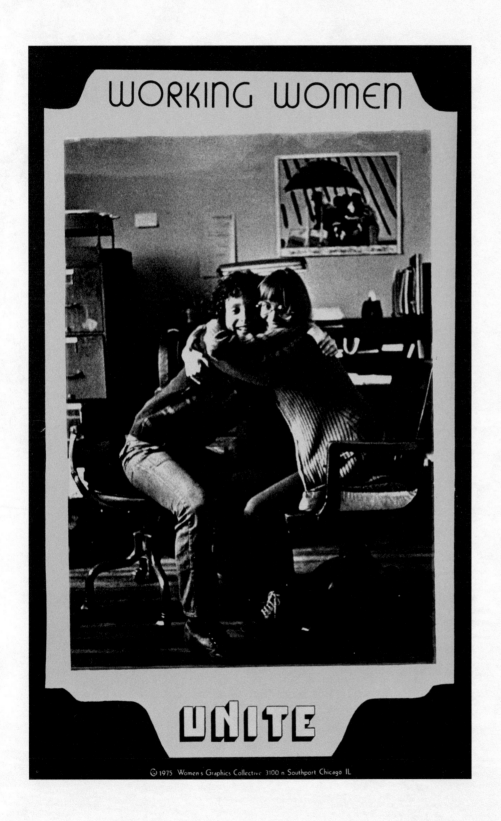

Figure 72.

"Woman power," A. Philip Randolph Institute, 1970s. The A. Philip Randolph Institute was founded in 1965 by Randolph and Bayard Rustin to forge "an alliance," according to the institute's mission statement, between the labor and civil rights movements, thus uniting the fight to achieve the twin goals of political freedom and economic justice.

Tamiment Library Poster and Broadside Collection (GRAPHICS 002), Flat File 7, Drawer 3, Tamiment Library and Robert F. Wagner Labor Archives, New York University.

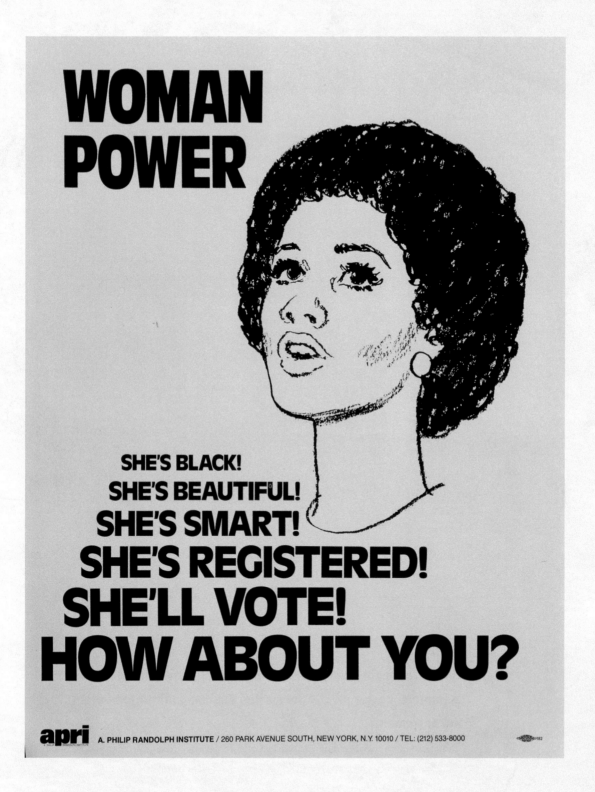

Figure 73.

"In education, in marriage, in everything," Times Change Press, 1970. A feminist poster vividly portraying the disappointment that is "the lot of woman."

Tamiment Library Poster and Broadside Collection (GRAPHICS 002), Flat File 7, Drawer 3, Tamiment Library and Robert F. Wagner Labor Archives, New York University.

In education, in marriage, in every-
thing, disappointment is the lot of wo-
man. It shall be the business of my life
to deepen this disappointment in every
woman's heart until she bows down to
it no longer.

Lucy Stone, 1855

STONE TCP-2 © 1970 Times Change Press

Figure 74.

"Fuck housework," Virtue Hathaway, nom de plume of Shirley J. Boccaccio, originally published in 1971. This one says it all.

Tamiment Library Poster and Broadside Collection (GRAPHICS 002), Flat File 7, Drawer 3, Tamiment Library and Robert F. Wagner Labor Archives, New York University.

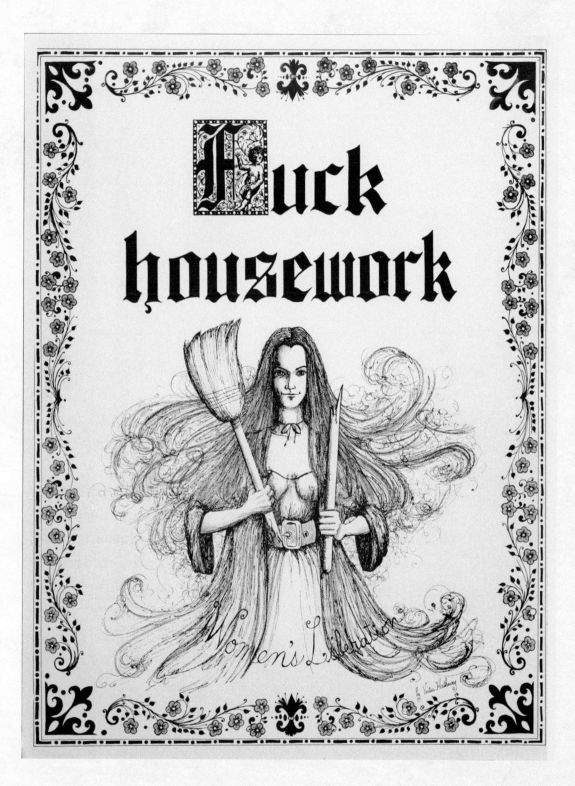

Figure 75.

"Leave your jewels in the bank and buy a revolver," artist unknown, 1970s. The quote is from Constance de Markievicz, the notorious countess who took part in the 1916 Easter Rising in Dublin. In 1918 she became the first woman elected to Britain's House of Commons.

Tamiment Library Poster and Broadside Collection (GRAPHICS 002), Flat File 7, Drawer 3, Tamiment Library and Robert F. Wagner Labor Archives, New York University.

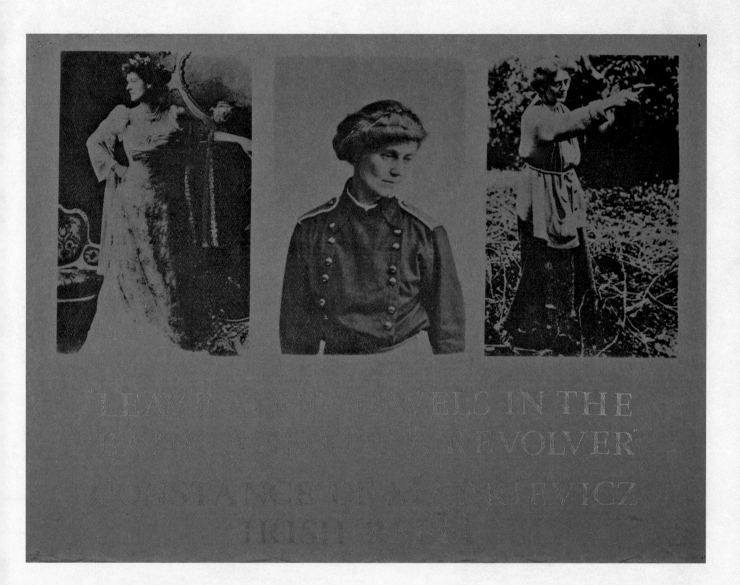

"LEAVE YOUR JEWELS IN THE
BANK AND BUY A REVOLVER"
CONSTANCE DE MARKIEVICZ
IRISH REBEL

Figure 76.

"Don't call me girl!," Chicago Women's Graphics Collective, c. 1975.

Courtesy of the CWLU Herstory Project, www.cwluherstory.org.

Tamiment Library Poster and Broadside Collection (GRAPHICS 002), Flat File 7, Drawer 3,
Tamiment Library and Robert F. Wagner Labor Archives, New York University.

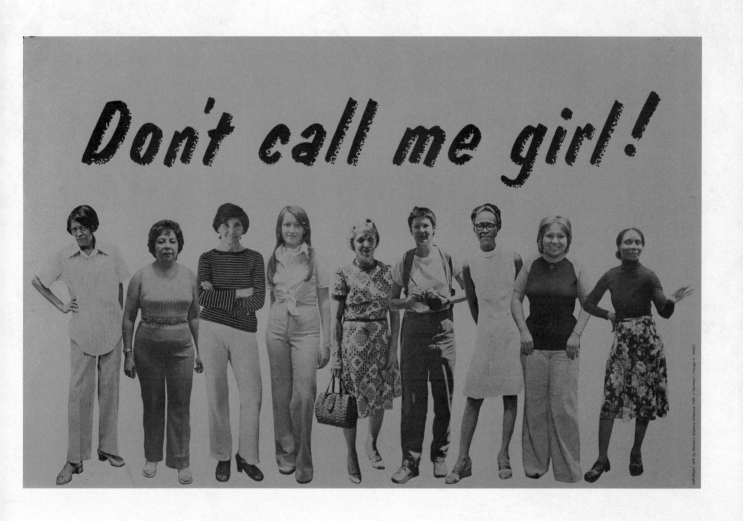

Figure 77.

"Women's liberation forum," NYU Women's Liberation Front, 1970s.

Tamiment Library Poster and Broadside Collection (GRAPHICS 002), Flat File 7, Drawer 3, Tamiment Library and Robert F. Wagner Labor Archives, New York University.

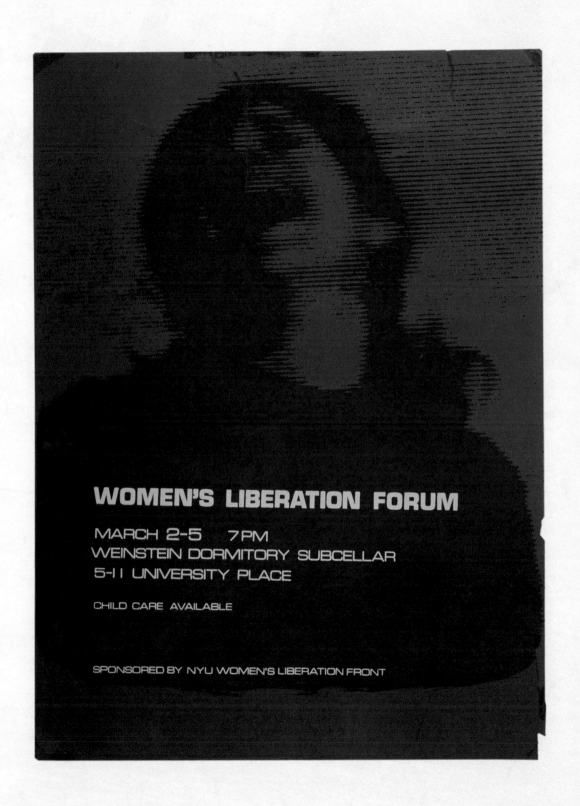

WOMEN'S LIBERATION FORUM

MARCH 2-5 7PM
WEINSTEIN DORMITORY SUBCELLAR
5-11 UNIVERSITY PLACE

CHILD CARE AVAILABLE

SPONSORED BY NYU WOMEN'S LIBERATION FRONT

Figure 78.

"Jail the rapist . . . not the victim!," Helen Kudatsky, 1970s.

Tamiment Library Poster and Broadside Collection (GRAPHICS 002), Flat File 7, Drawer 4, Tamiment Library and Robert F. Wagner Labor Archives, New York University.

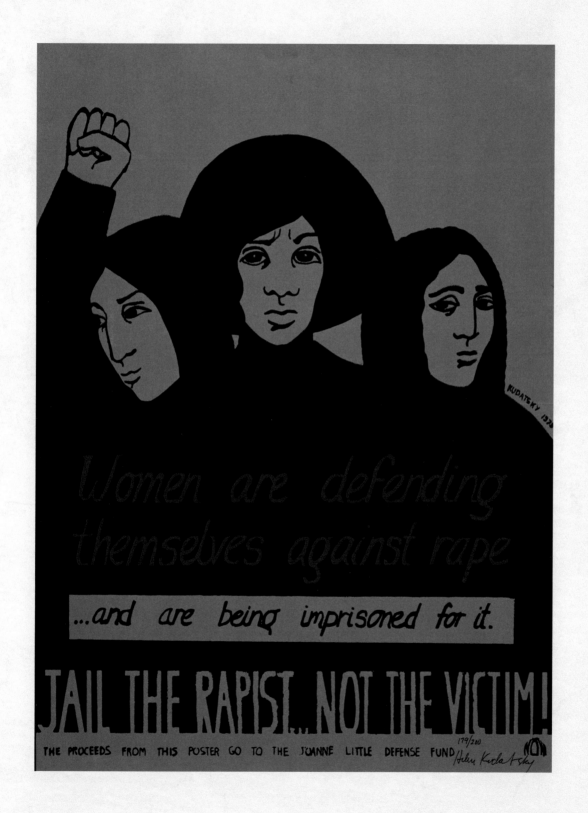

Women are defending themselves against rape

...and are being imprisoned for it.

JAIL THE RAPIST... NOT THE VICTIM!

THE PROCEEDS FROM THIS POSTER GO TO THE J'OANNE LITTLE DEFENSE FUND

179/200

Figure 79.

Reproduction of a poster by José Gómez Fresquet, printed by the Chicago Women's Graphics Collective, 1967. By juxtaposing the images of a glamorous Western woman applying lipstick, and a Vietnamese woman with a bloody nose, this poster has both a feminist theme and an anti–Vietnam War theme. Courtesy of the CWLU Herstory Project, www.cwluherstory.org.

Tamiment Library Poster and Broadside Collection (GRAPHICS 002), Flat File 7, Drawer 4, Tamiment Library and Robert F. Wagner Labor Archives, New York University.

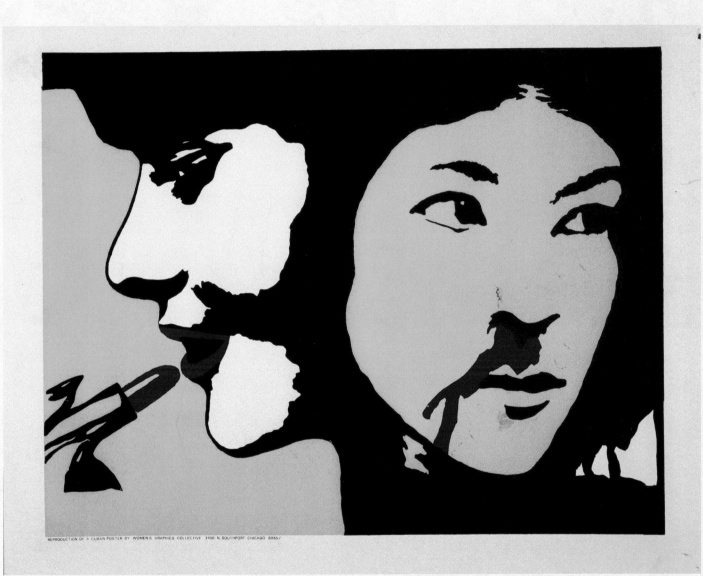

REPRODUCTION OF A CUBAN POSTER BY WOMEN'S GRAPHICS COLLECTIVE 3100 N SOUTHPORT CHICAGO 60657

Figure 80.

"Gay liberation," graphic design by Sue Negrin, photograph by Peter Hujar, mandala by Suzanne Bevier for Times Change Press, 1970.

Tamiment Library Poster and Broadside Collection (GRAPHICS 002), Flat File 7, Drawer 2, Tamiment Library and Robert F. Wagner Labor Archives, New York University.

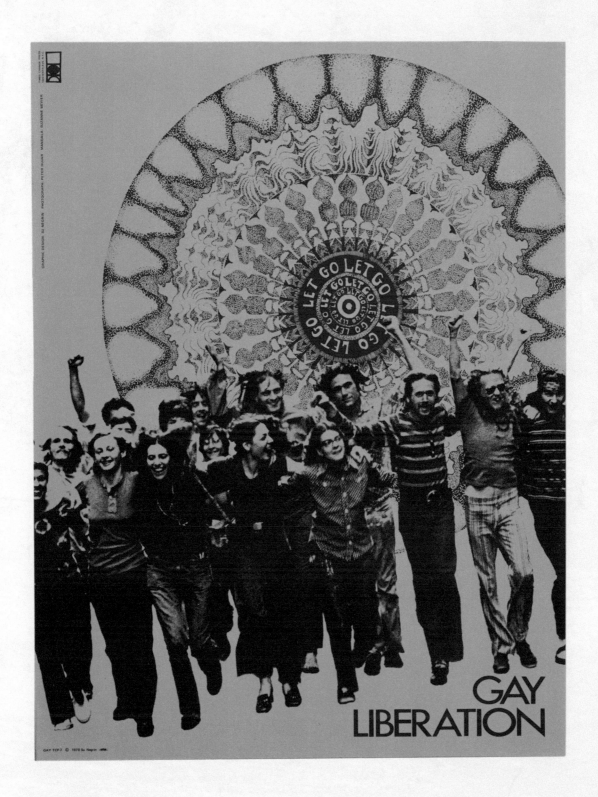

GAY
LIBERATION

Figure 81.

"Gay awareness week," UC Berkeley's Gay People's Union, 1970s.

Tamiment Library Poster and Broadside Collection (GRAPHICS 002), Flat File 7, Drawer 2, Tamiment Library and Robert F. Wagner Labor Archives, New York University.

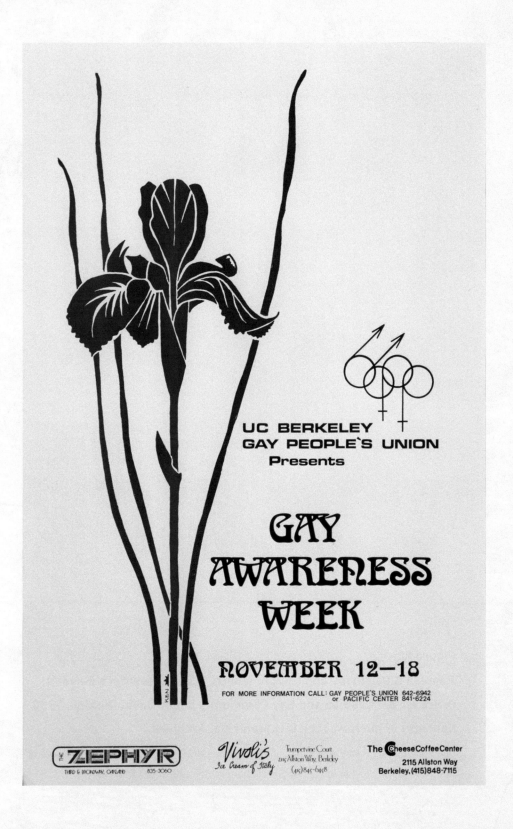

Figure 82.

"Lesbian & Gay Pride and History Month," City of New York Mayor's Office for the Lesbian and Gay Community under David Dinkins, 1990. Courtesy of the New York City Municipal Archives.

Tamiment Library Poster and Broadside Collection (GRAPHICS 002), Flat File 7, Drawer 2, Tamiment Library and Robert F. Wagner Labor Archives, New York University.

NEW

YORK

CITY

JUNE 90

Gertrude "Ma" Rainey
Appeared in Harlem theaters in 1923 and 1926; recorded in New York in 1924-25. Unique in pre-Stonewall American history is an assertive song of lesbian self-affirmation, "Prove It On Me Blues," written, performed, and recorded by Ma Rainey in 1928 in the character of a woman who proclaims her sexual interest in women and challenges the world to "prove it on me." Photo, Mother of the Blues, by Sandra Lieb (University of Massachusetts Press, 1981).

Transvestite
A cross-dresser, arrested by the New York City police in the 1940s, photographed by the famous Weegee (Arthur Fellig). Photo, courtesy of Wilma Wilcox.

Beebo Brinker
by Ann Bannon
In 1962, this paperback novel's heroine "landed in New York" with the "desperation of a girl whose only certainty was that she was 'different'."

LESBIAN

"The Captive"
by Edouard Bourdet
This play, translated from the French, opened on Broadway in 1926. As it ended in heroine, the captive, left her man, drawn by the powerful attraction of a mysterious female captivation - a patriarchal nightmare of the 1920s.

"The Masculine Woman"
A postcard produced by a New York company in 1905 was one of those which mocked women who wore "mannish" clothes and mixed independently in the world - expressing men's anxiety about changes in traditional notions of femininity and masculinity.

& GAY

Gore Vidal
In 1948, the New York Times review of Gore Vidal's The City and the Pillar suggested there were already too many novels about homosexuals. "Presented as the case history of a standard homosexual this novel adds little that is new to a groaning shelf."

Pride
AND
History

Willa Cather
One night in 1899, back-stage at a Pittsburgh theater, Cather met Isabelle McClung, the great romance of her life, at whose home Cather would write her novels O Pioneers! and The Song of the Lark. In 1903, Cather came to New York to work at McClure's magazine and made the City her home. Photo: Edward Steichen, courtesy Alfred Knopf, Inc.

Goldie
by Kennilworth Bruce
This novel, published in New York in 1933, is "The story of an unusual venture into the land of Twilight Sex" - telling how an "All-American football player...emerges as Goldie, the Degenerate, one of the most notorious inverts of Limbo..."

GOLDIE

BRUCE

GODWIN BY KENNILWORTH BRUCE

City of New York
Mayor's Office for the Lesbian and Gay Community
52 Chambers Street
Room 315
New York, NY 10007

Bulk Rate
US Postage
P A I D
New York, NY
Permit No. 8095

M O N T H

Federico García Lorca
After visiting New York in 1929, the Spanish poet wrote his "Ode to Walt Whitman," in which Whitman symbolizes a homosexuality free of shame, though Lorca's disparagement of effeminate homosexuals indicates he had not yet come to terms with his own homosexuality. Photo: Federico García Lorca: A Life by Ian Gibson (Pantheon, 1989).

Bayard Rustin
Fifteen days before the 1963 March on Washington for African-American civil rights, Sen. Strom Thurmond of South Carolina tried to stop the upcoming demonstration by publicly fingerpointing and red-baiting Rustin, the march's chief organizer, a New Yorker. Civil rights leaders supported Rustin, however, and the march went on.

This poster was funded by the City of New York, Office for the Lesbian and Gay Community.

Director: Dr. Marjorie Hill
Coordination: Jeri Carl Park

Concept and Text: Jonathan Ned Katz

Design: David B. Gibson

Production: Susan Horowitz

Printing: Tower Press Communications.

Figure 83.

"Sisterhood feels good," Donna Gottschalk for Times Change Press, 1971.

Tamiment Library Poster and Broadside Collection (GRAPHICS 002), Flat File 7, Drawer 2, Tamiment Library and Robert F. Wagner Labor Archives, New York University.

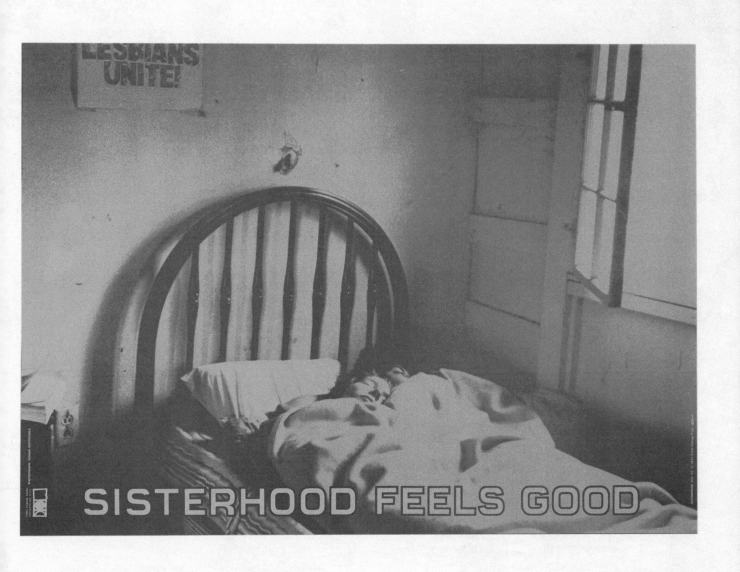

Figure 84.

"And the men ask, 'Where is your Shakespeare?'" Chicago Women's Graphics Collective, 1976. A poster for the Third Annual Lesbian Writers Conference. Courtesy of the CWLU Herstory Project, www.cwluherstory.org.

Tamiment Library Poster and Broadside Collection (GRAPHICS 002), Flat File 7, Drawer 2, Tamiment Library and Robert F. Wagner Labor Archives, New York University.

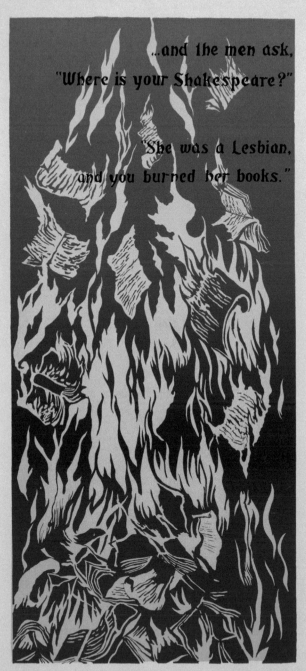

Third Annual Lesbian Writers Conference
September 17, 18 & 19 Chicago, Illinois

Contact: Womanpress Box 59330 Chicago Illinois 60643 312-334-8561
Copyright 1976 by the Womens Graphics Collective 3100 N Southport Chicago 60657

Figure 85.

"Our land is more valuable than your money," photograph of Chief Curlyhead, calligraphy by Veronica Chapman, for *Akwesasne Notes*, 1970s.

Tamiment Library Poster and Broadside Collection (GRAPHICS 002), Flat File 7, Drawer 3, Tamiment Library and Robert F. Wagner Labor Archives, New York University.

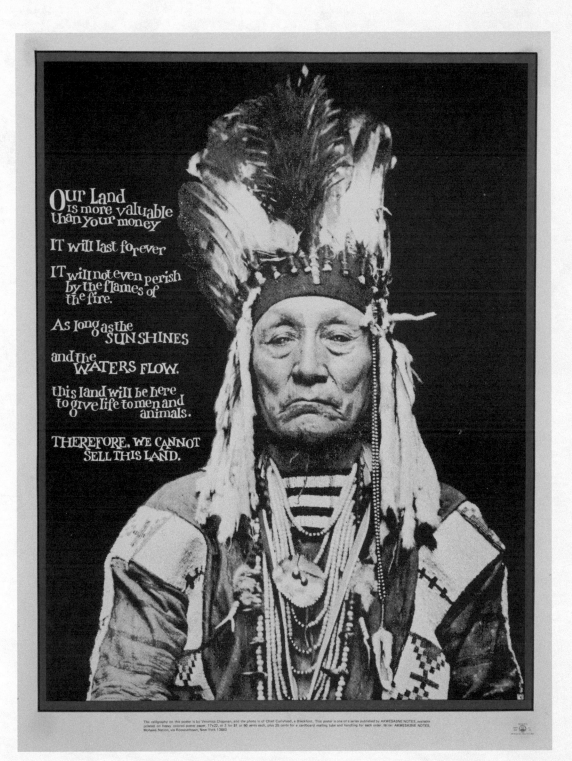

Figure 86.

"Respect our vision," Menominee Solidarity Committee, Menominee Warrior Society, Peoples Committee, 1970s.

Tamiment Library Poster and Broadside Collection (GRAPHICS 002), Flat File 7, Drawer 3, Tamiment Library and Robert F. Wagner Labor Archives, New York University.

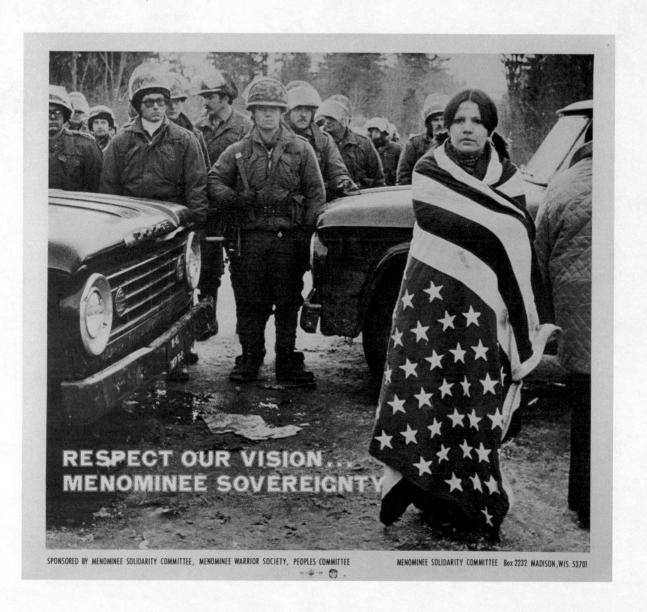

RESPECT OUR VISION...
MENOMINEE SOVEREIGNTY

SPONSORED BY MENOMINEE SOLIDARITY COMMITTEE, MENOMINEE WARRIOR SOCIETY, PEOPLES COMMITTEE MENOMINEE SOLIDARITY COMMITTEE Box 2232 MADISON, WIS. 53701

Figure 87.

"Remember Wounded Knee," artist unknown, probably 1973.

Tamiment Library Poster and Broadside Collection (GRAPHICS 002), Flat File 7, Drawer 3, Tamiment Library and Robert F. Wagner Labor Archives, New York University.

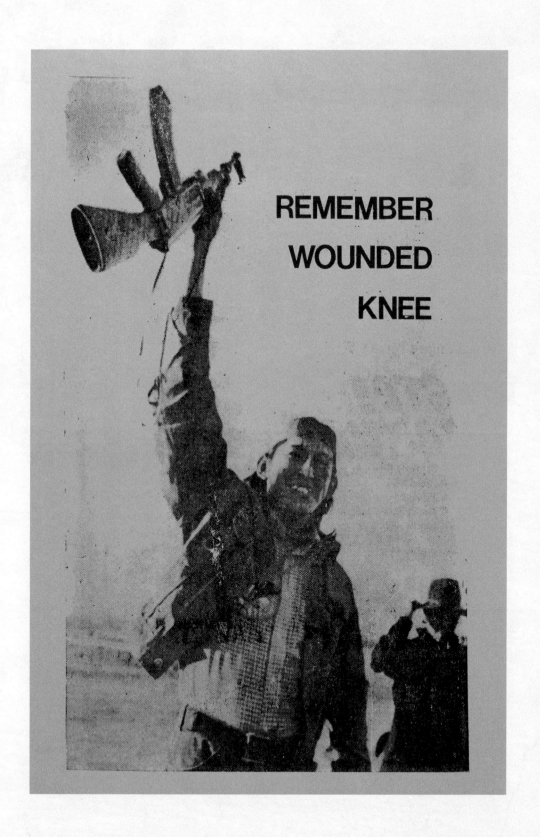

REMEMBER
WOUNDED
KNEE

A Note on the Tamiment Library and Robert F. Wagner Labor Archives Poster and Broadside Collection at New York University

The Tamiment Library and Robert F. Wagner Labor Archives is one of the oldest special collections in the country devoted to the history of the Left, political radicalism, labor, and social protest movements. Tracing its origins to the library of the Rand School for Social Science, a Socialist workers' education school founded in 1906, the collections in the Tamiment Library and Wagner Labor Archives now include over 20,000 linear feet of archives and manuscripts, 15,000 labor, alternative, and underground press periodical titles, more than 75,000 monographs, 850,000 pamphlets and ephemera, and over a million photographs. Notable archival collections include the archives of the Communist Party of the United States, records of the National Lawyers Guild and the Center for Constitutional Rights, the Abraham Lincoln Brigade Archives, and several women's history collections including the records of the New York chapter of the National Organization for Women, as well as personal papers collections from the civil rights activists James and Esther Cooper Jackson, the historian Howard Zinn, the lawyer William Kunstler, and the alleged spy Alger Hiss.

The Tamiment Library and Wagner Labor Archives collections provide a rich visual history of the Left, progressive movements, labor unions, and the counterculture and include over 2,900 posters and broadsides dating from 1904 to the present. The collection documents radical politics in

the United States with posters from a broad range of political parties, including the Communist Party of the United States, various socialist parties, the American Labor Party, the Peace and Freedom Party, and the Workers Party. Also in the collection are a broad range of materials documenting the trade-union movement, such as posters from the Industrial Workers of the World, United Farm Workers, International Ladies' Garment Workers' Union, Amalgamated Clothing Workers of America, Independent Federation of Flight Attendants, American Federation of Labor, Transport Workers Union of America, and many more. The collection also holds posters on more general topics such as housing and public transit that intersect with social and political issues, as well as a small group of posters that illustrate pro–Vietnam War, antiradical and antilabor points of view.

One of the collection's strengths is its extensive documentation of social protest and justice movements. Materials on the civil rights and Black Power movements include posters produced by the Student Nonviolent Coordinating Committee (SNCC), Southern Christian Leadership Conference (SCLC), Congress of Racial Equality (CORE), A. Philip Randolph Institute, Black Panther Party, Baraka Defense Committee, and Mississippi Freedom Democratic Party. The women's liberation movement posters include materials in support of the Equal Rights Amendment, International Women's Day, lesbian rights, health and reproductive rights, and women of color and include posters from the National Organization for Women, National Association of Working Women, and many grassroots organizations. Other social movements represented in the Tamiment poster collection include the Native American, gay liberation, and anti–Vietnam War movements; the latter includes posters from GI groups such as the Vietnam Veterans Against the War and the Fort Dix 38, peace and disarmament organizations, and student protest groups such as Students for a Democratic Society.

While the majority of the posters in the collection are from the United States, the collection also includes posters produced outside the US, with some of the largest groupings of posters from Cuba, the People's Republic of China, Japan, Great Britain, Czechoslovakia, and Spain, with over 230 posters produced by leftist political parties, labor unions, and other organizations that supported the Spanish Republican government during the Spanish Civil War from 1936 to 1938. The international posters in the collection cover a broad range of issues, although many focus on themes of anti-imperialism, antifascism, communism, liberation, and disarmament.

INDEX

Page numbers in *italics* refer to the images.

ABOUT THE EDITOR

Ralph Young is a professor of History at Temple University. He has won several major teaching awards and is the author of *Dissent: The History of an American Idea*, a narrative history of the United States from the perspective of dissenters and protest movements, and editor of *Dissent in America: The Voices That Shaped a Nation*, a collection of four hundred years of dissenting speeches, petitions, letters, songs, poems, and essays that called for change, reform, or even revolution. He is also the founder of weekly campus-wide teach-ins at Temple in which students and faculty examine the historical context of controversial contemporary issues.

WITHDRAWN

MORRIS AUTOMATED INFORMATION NETWORK

0 1004 0309722 1

WITHDRAWN

DATE DUE

This item is Due on
or before Date shown.

FEB - - 2017